In memory of Rette and
Karen Murray.

BALLERINA

BOB CAREY

Introduction by Amy Arbus Text by Kathleen Vanesian Picture Editor, Laurie Kratochvil

Library of Congress Cataloging-in-Publication Data Available

ISBN: 978-0-9858583-0-8

Bob Carey, photographer
Laurie Kratochvil, picture editor
Amy Arbus, writer
Kathleen Vanesian, writer
P.S. Studios, Inc., design

thetutuproject.com
bobcarey.com

Dedicated to my beautiful wife Linda, my mom and dad,

my two sisters, and to every person in the world who has been

touched by this life-changing disease.

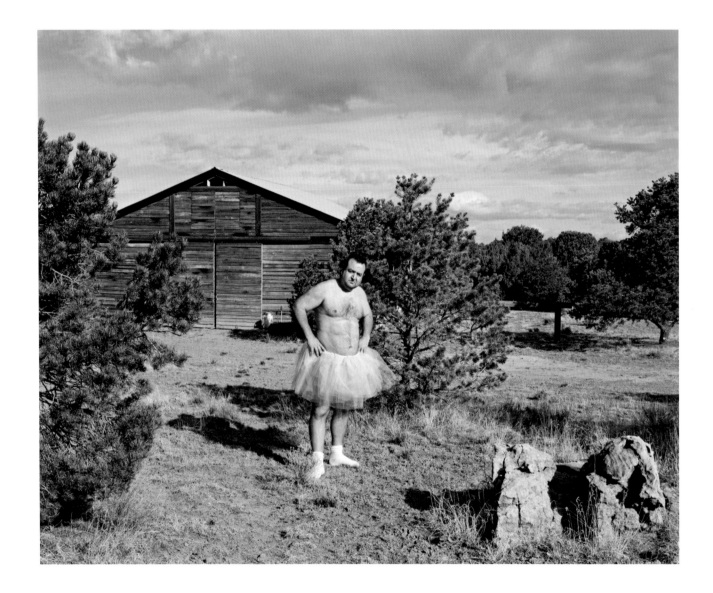

BARN SANTA FE, NEW MEXICO 2003

A MAN AND HIS TUTU

Bob Carey is completely disarming, both with his kindness and his candor. He is a big, warm-hearted teddy bear of a guy, full of eagerness and humility, and deeply smitten with photography. In 1993, well into a successful advertising career, he began a series of self-portraits that exposed a man in both physical and emotional distress. These images consisted of strangely shaped heads created by wrapping himself in monofilament fishing line or by hanging himself upside down with "an engine hoist apparatus." He often frequented a nearby salvage yard in his native Phoenix, Arizona, subsequently painting himself silver with a talcum powder-like make-up, wearing either a smooth aluminum cover over his face

or two lighting fixtures as ears. The effect of the images is startling – a person who is part man, part machine. Although his black & white film was spectacularly exposed and the photographs themselves expertly printed, they are challenging, in particular because of the obvious discomfort it took to make them. As Bob has said, "When I was wrapping myself, although it hurt, it was almost comforting, like being held." For the viewer, each photograph looks like a test of his pain threshold. I think of him as "the escape artist of photography."

In *Ballerina,* Bob appears reborn. The series, which began in 2003 as he and his wife Linda Lancaster-Carey were driving across the country, moving from

Phoenix to Brooklyn, New York, is comprised of super-saturated color self-portraits that achieve an almost surreal effect. They feel child-like in their innocence, and illustrate Bob as a man with an endless fascination for life. In the photographs, Bob is always alone, outfitted in a pink tutu: praying at the ocean in Coney Island, lying in a hotel room in Wildwood, New Jersey in a single of twin beds, otherwise naked on a snow covered street in Brooklyn, or with his head in his hands at the school bus parking lot in New York. He is often running away from the camera, remote in hand to trip the shutter, jumping for joy and caught in the stop action of daylight strobe. Sometimes his gestures are repetitive, but the images he captures are anything but.

A MASTER OF INTRIGUING POINT-OF-VIEW, LIGHTING AND POETIC METAPHOR.

He is a master of intriguing point-of-view, lighting and poetic metaphor. When his father Gene helped him set up the photograph, *Shuffleboard, Arizona,* he announced proudly, to anyone and everyone, "That's my son."

When this project began, Bob's personality was apparent in the images, not necessarily his face or likeness. As time passed, the locations became more elaborate and, in turn, he became smaller in the frame. Bob has said of using himself as a model, "I'm always available," but as the series progressed, he acknowledged, "It's not about me anymore." Bob travels extensively across America looking for the perfect tree, putting green, cow pasture, airplane storage lot, construction site, forest or boardwalk. He climbs a fiberglass palm tree with blue palm fronds at

a hotel in Wildwood. He waits for a subway in Brooklyn that will never stop. In Monument Valley, he walks with trepidation on a road to nowhere.

The risks of photographing a series like *Ballerina* are numerous, but danger is an integral part of making the pictures. Bob has escaped getting busted by cops for indecent exposure by wearing matching pink shorts underneath his tutu and avoided being caught by security while trespassing on government property. When he's working, he hurries, so as not to be blown off the Chesapeake Bay Bridge or run over by a car in Times Square. He often finds himself in Monument Valley when the temperature is at extremes, either 15 degrees, or 115 degrees. As he recalls, "I am alone, without cell service and no one knows I am there." In

retrospect, he realizes this isn't so safe. I sense a new found feeling in him of vulnerability that comes with age, experience and the loss of those near and dear.

Equally, Bob's wife Linda is no stranger to danger. She has cheated death twice, once when she was diagnosed with cancer in 2003, and again in 2006. Ironically, it is her battle with the disease that kept this project alive, with Bob taking some time to work and travel and process her illness through his art. Now, Bob knows a whole community of cancer survivors and people still struggling with the disease. When he brings his tutu pictures to cancer clinics, where patients are wired for chemotherapy, he says, proudly, "As they are being injected with poison, I can see how much my photographs fill them with joy."

—*Amy Arbus*

IMAGES 2003 - 2012

ROLLER COASTER WILDWOOD, NEW JERSEY 2008

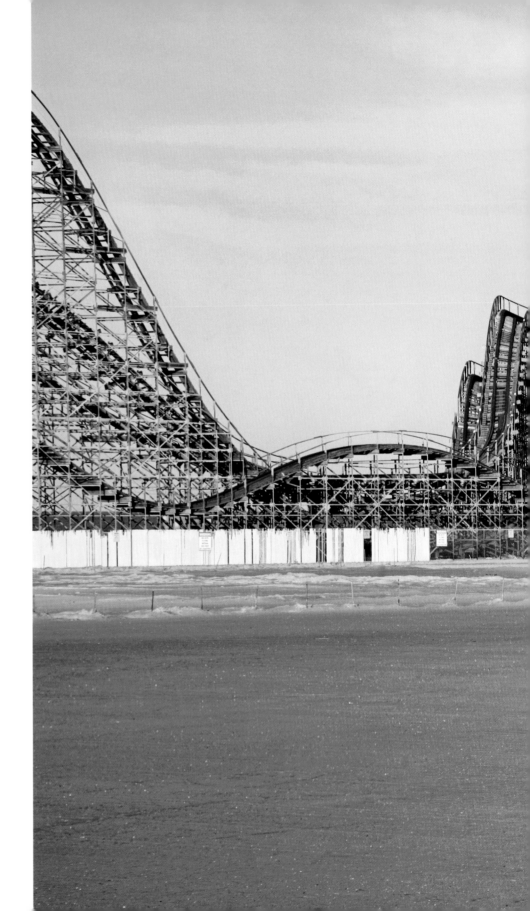

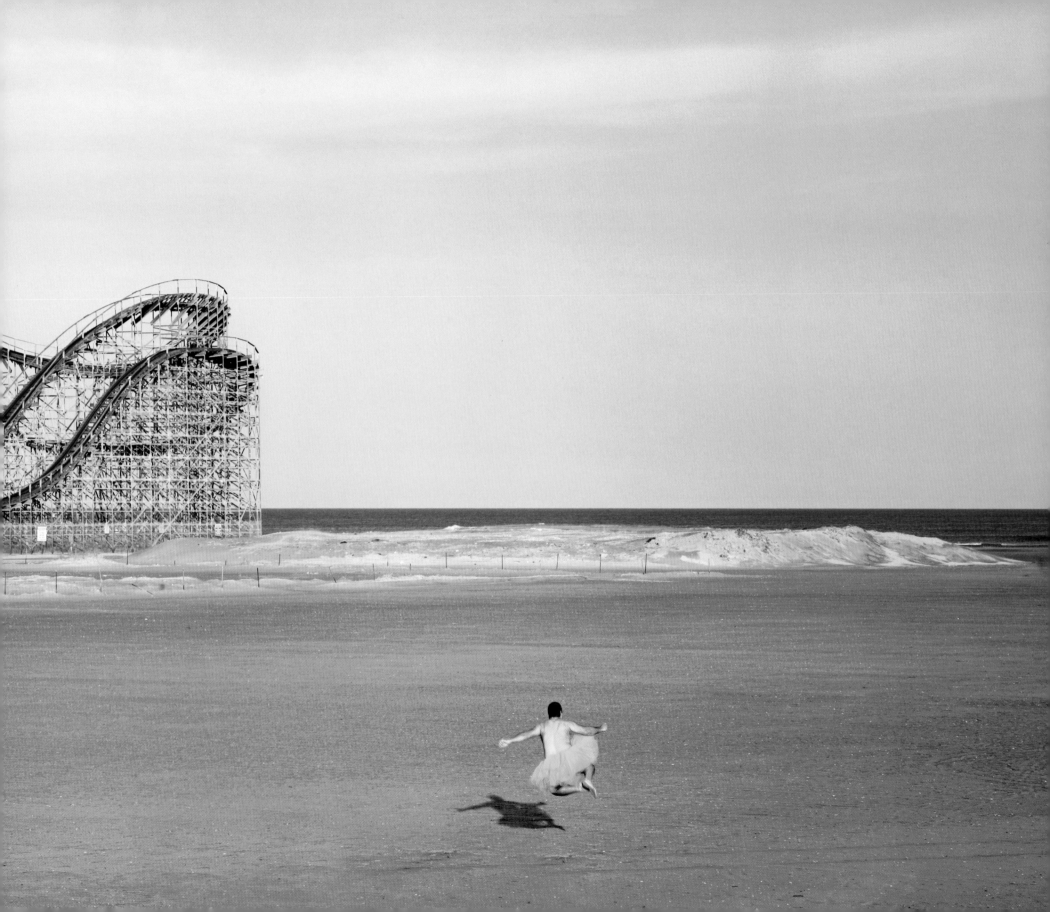

LAKE ARROWHEAD GAYLORD, MICHIGAN 2004

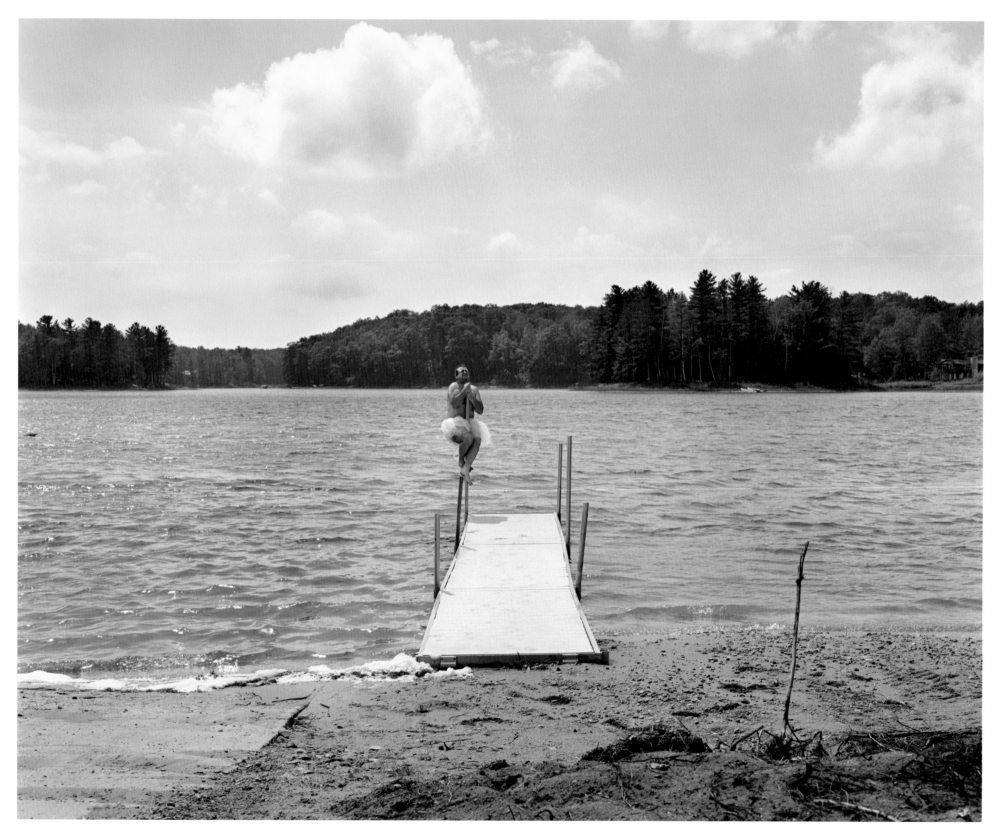

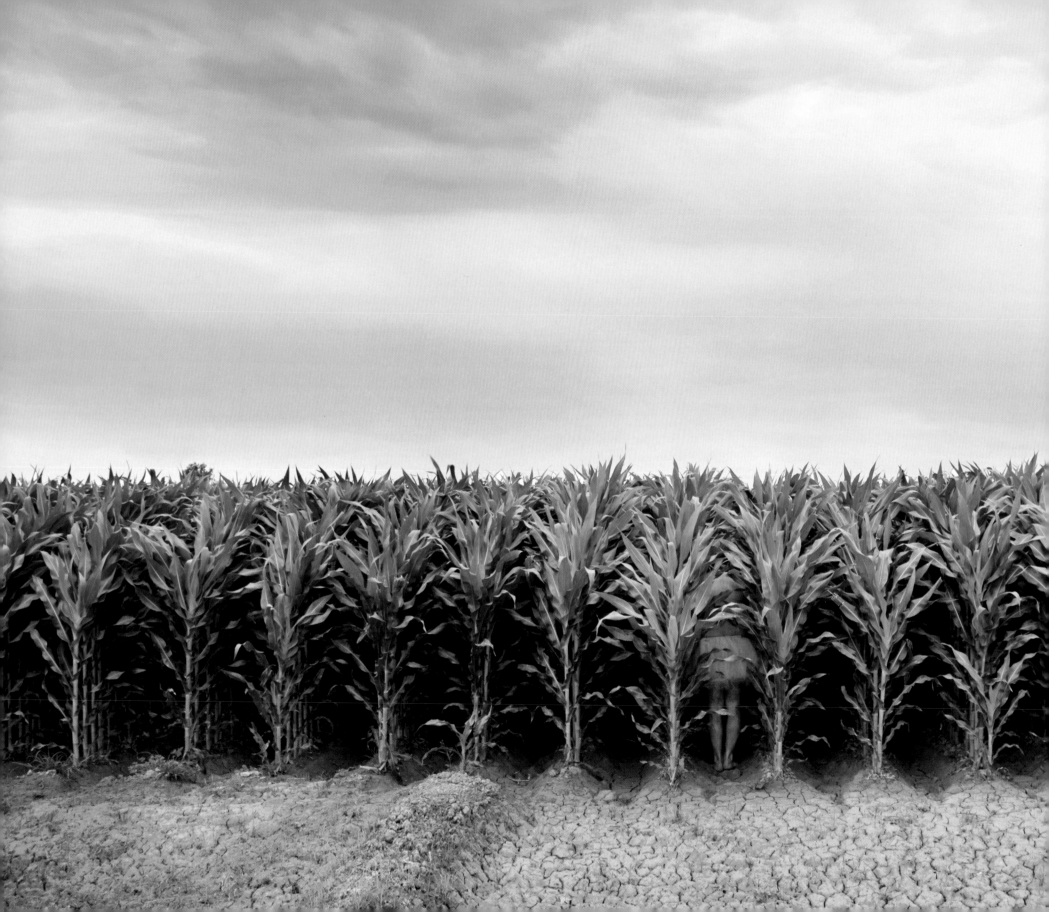

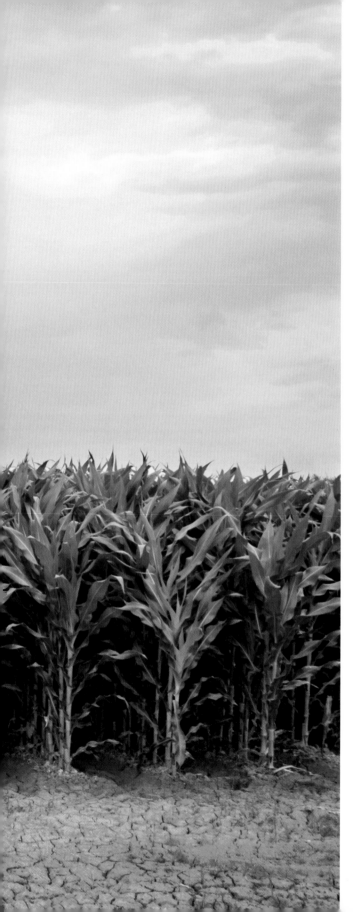

CORN QUEEN CREEK, ARIZONA 2009

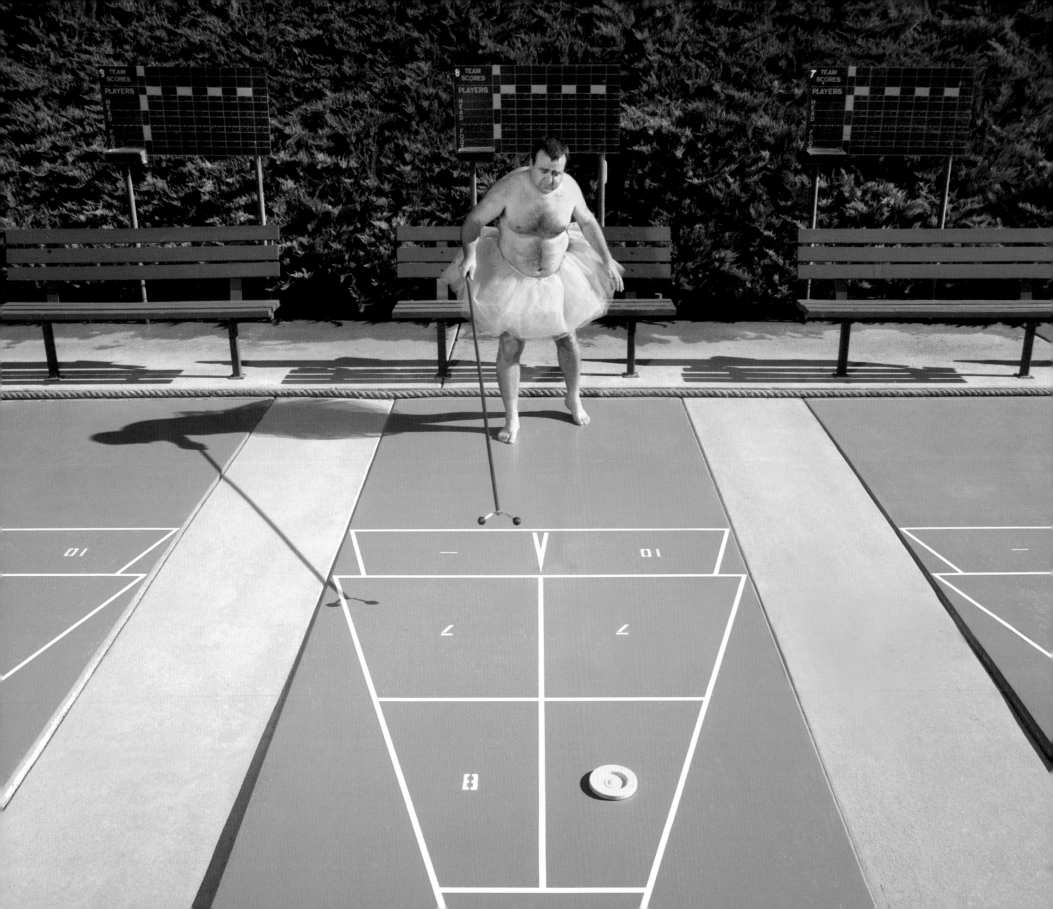

SHUFFLEBOARD MESA, ARIZONA 2004

SCHOOL BUS CONEY ISLAND, NEW YORK 2003

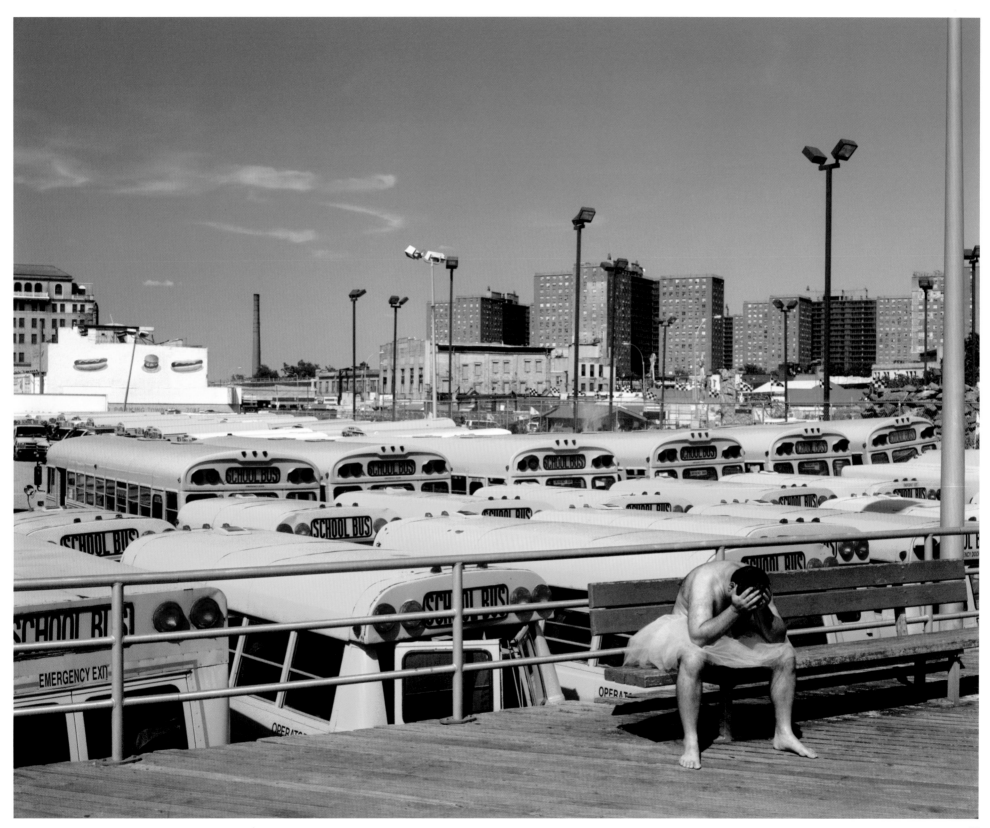

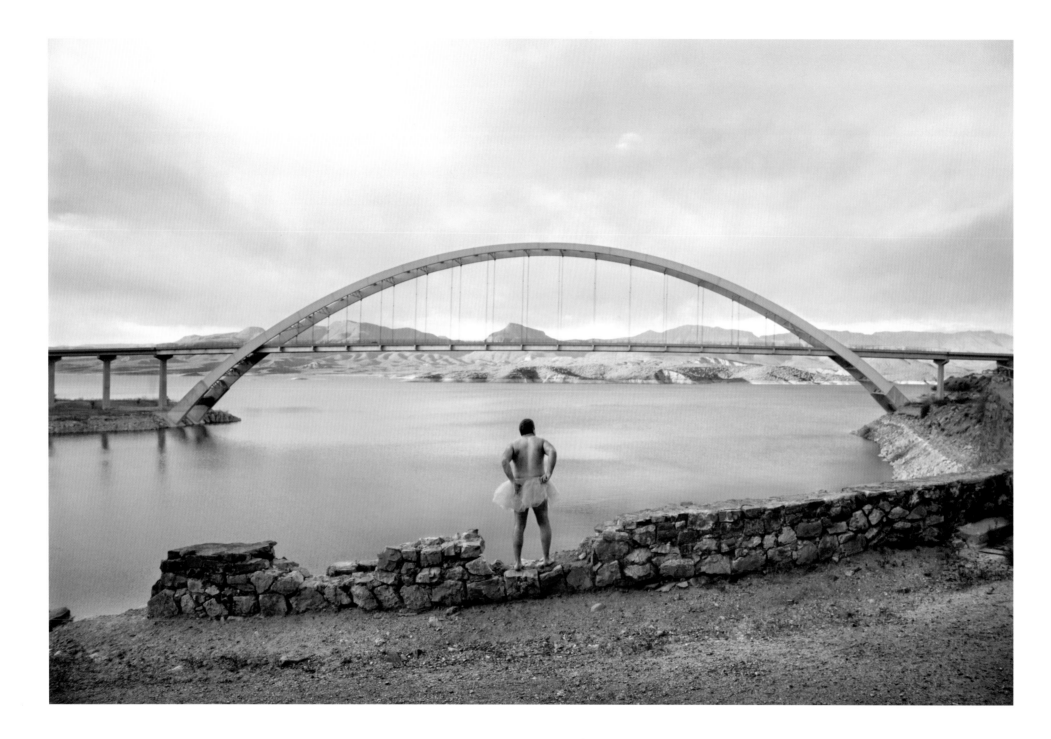

BLUE BRIDGE ROOSEVELT LAKE, ARIZONA 2012

MOTEL WILDWOOD, NEW JERSEY 2008

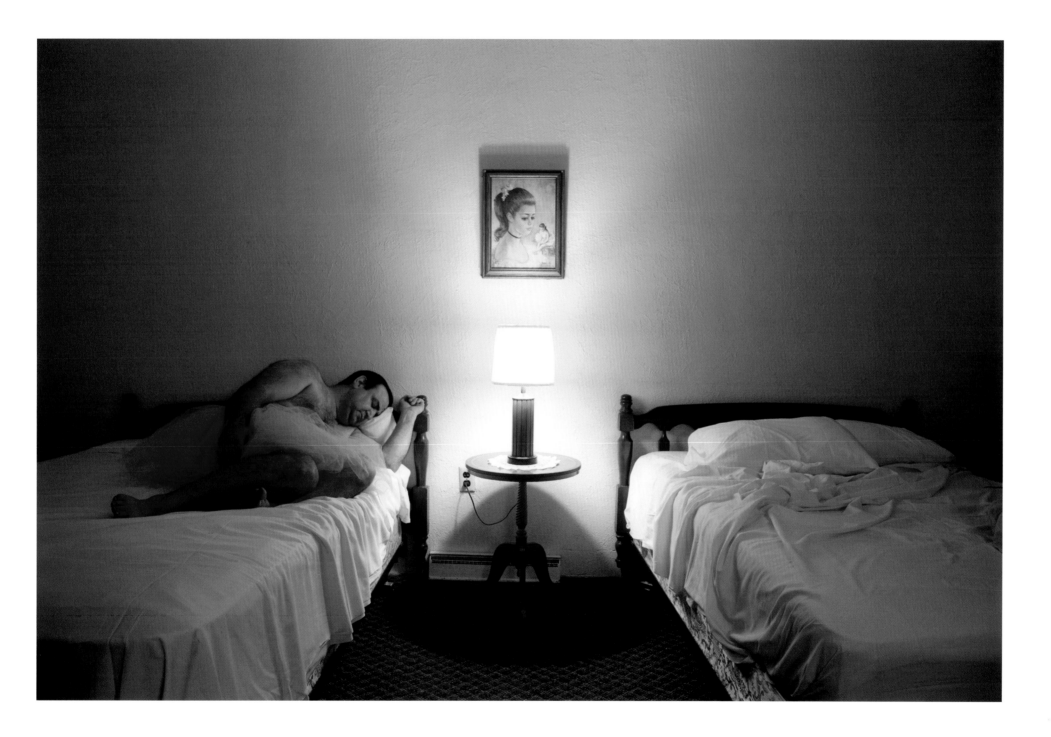

LOOKOUT POINT LONG ISLAND, NEW YORK 2012

WASHINGTON MONUMENT WASHINGTON D.C. 2012

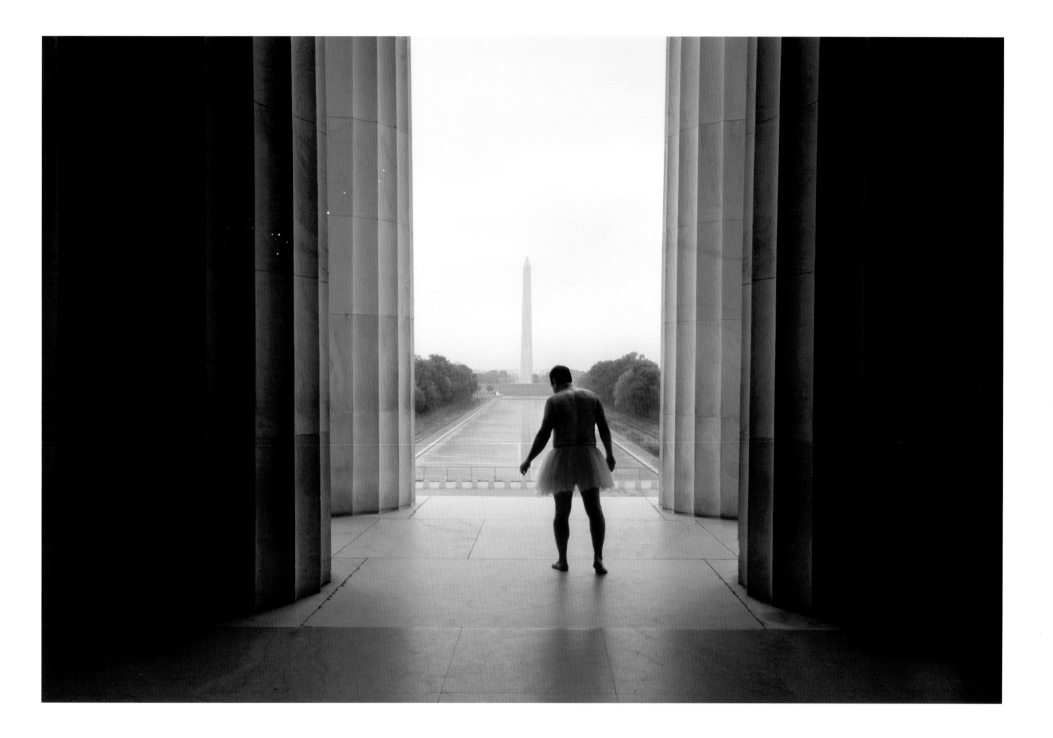

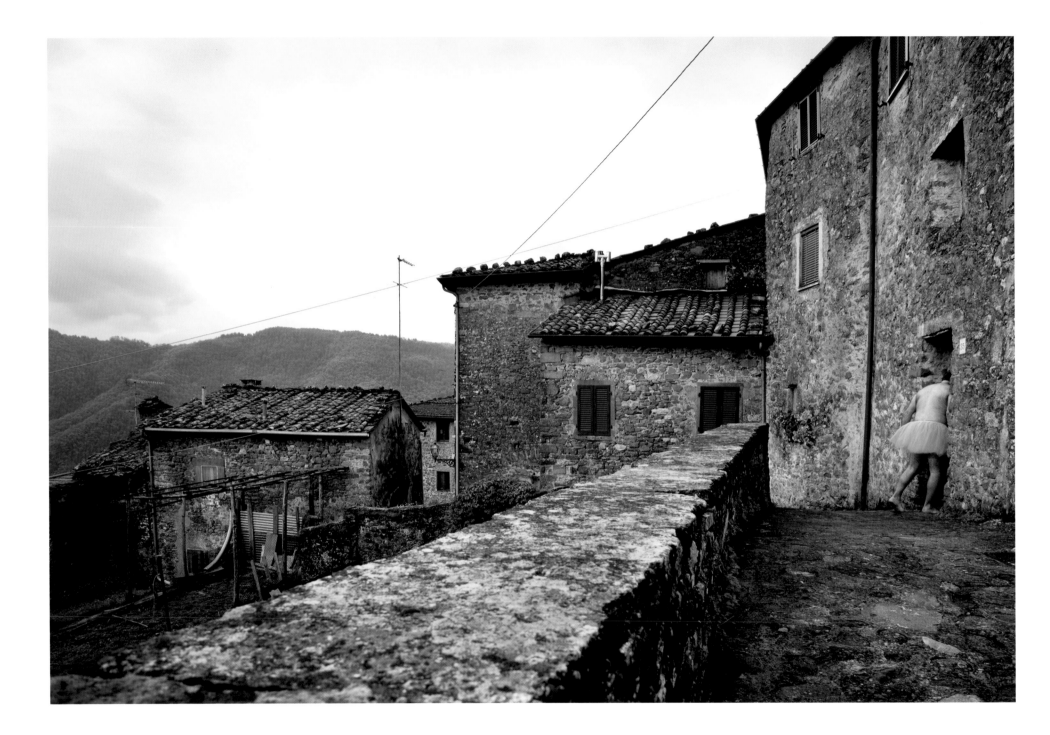

ITALY VITIANA, ITALY 2011

PALM TREES I-10 CALIFORNIA 2008

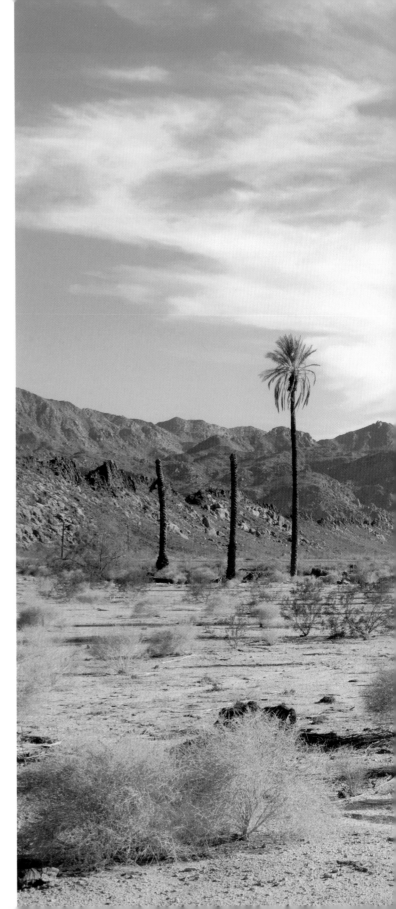

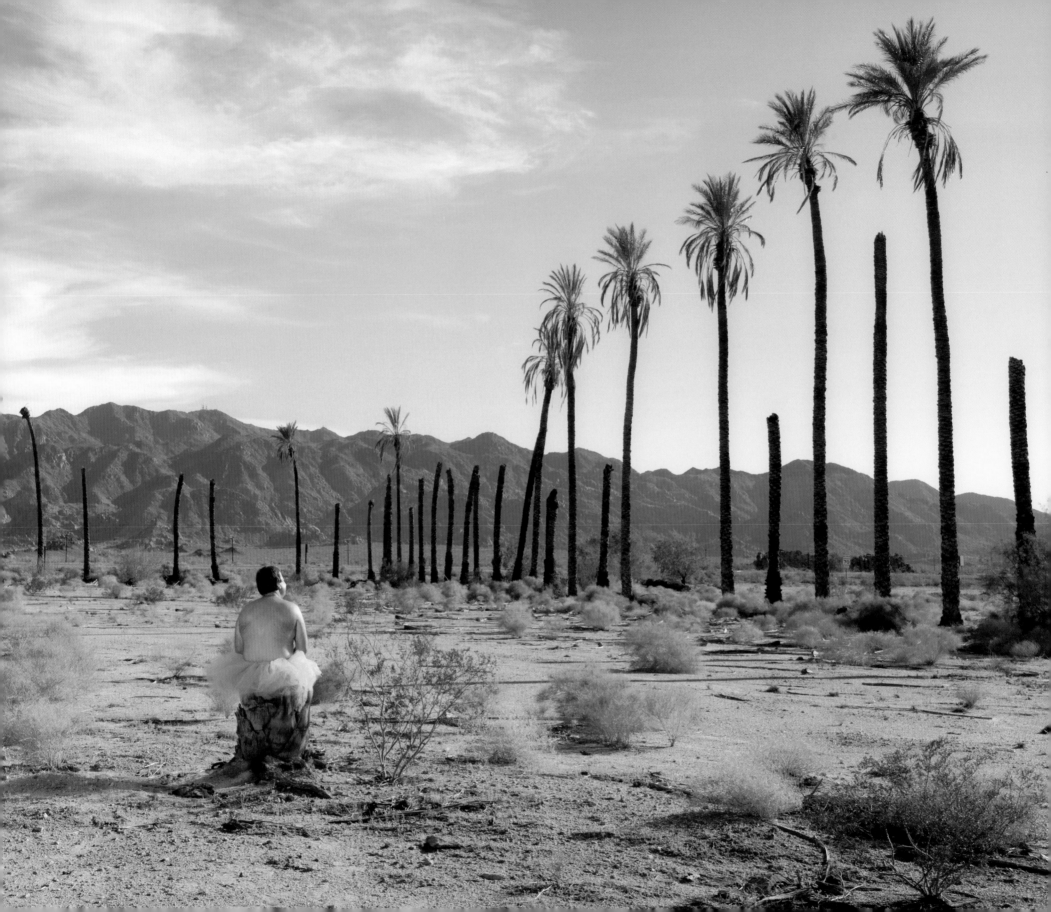

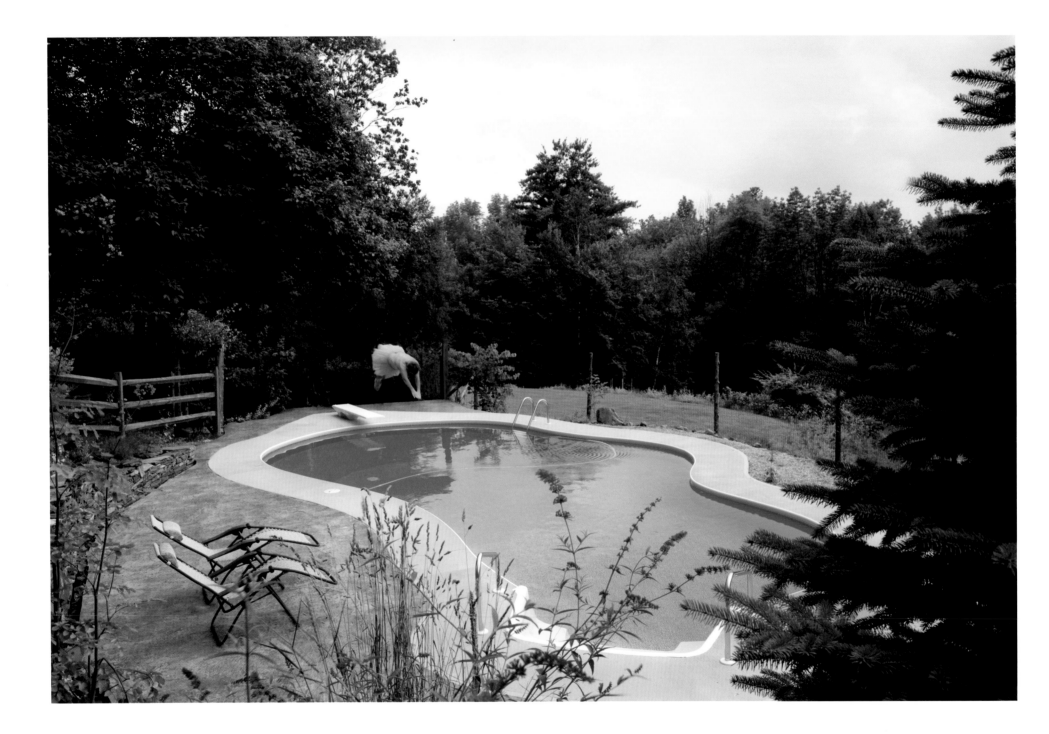

DIVE WOODSTOCK, NEW YORK 2008

DESERT ROCK WICKENBURG, ARIZONA 2008

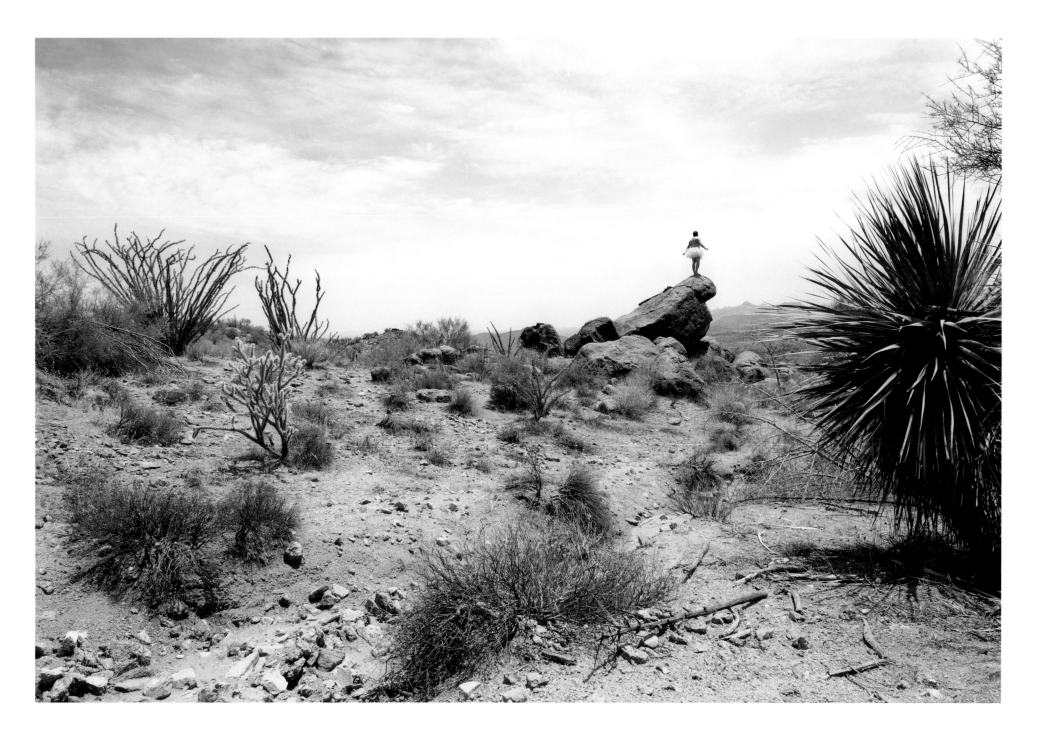

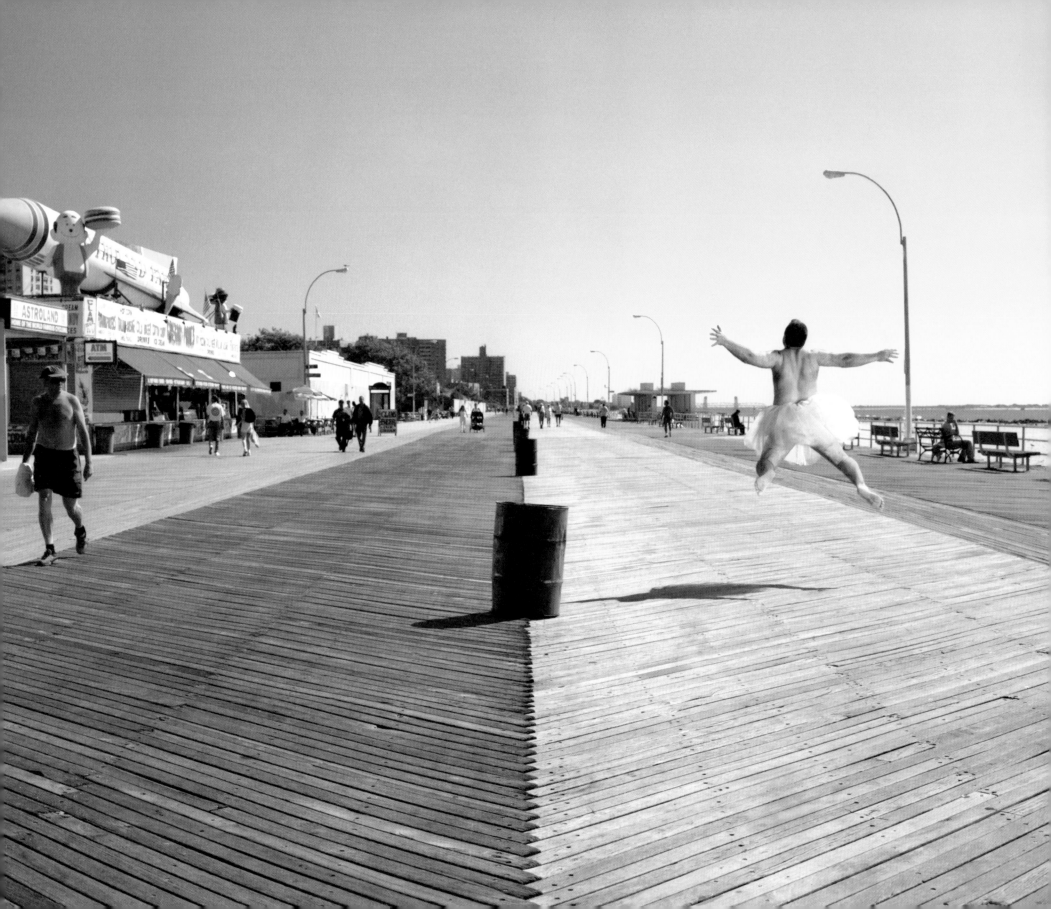

BOARDWALK CONEY ISLAND, NEW YORK 2003

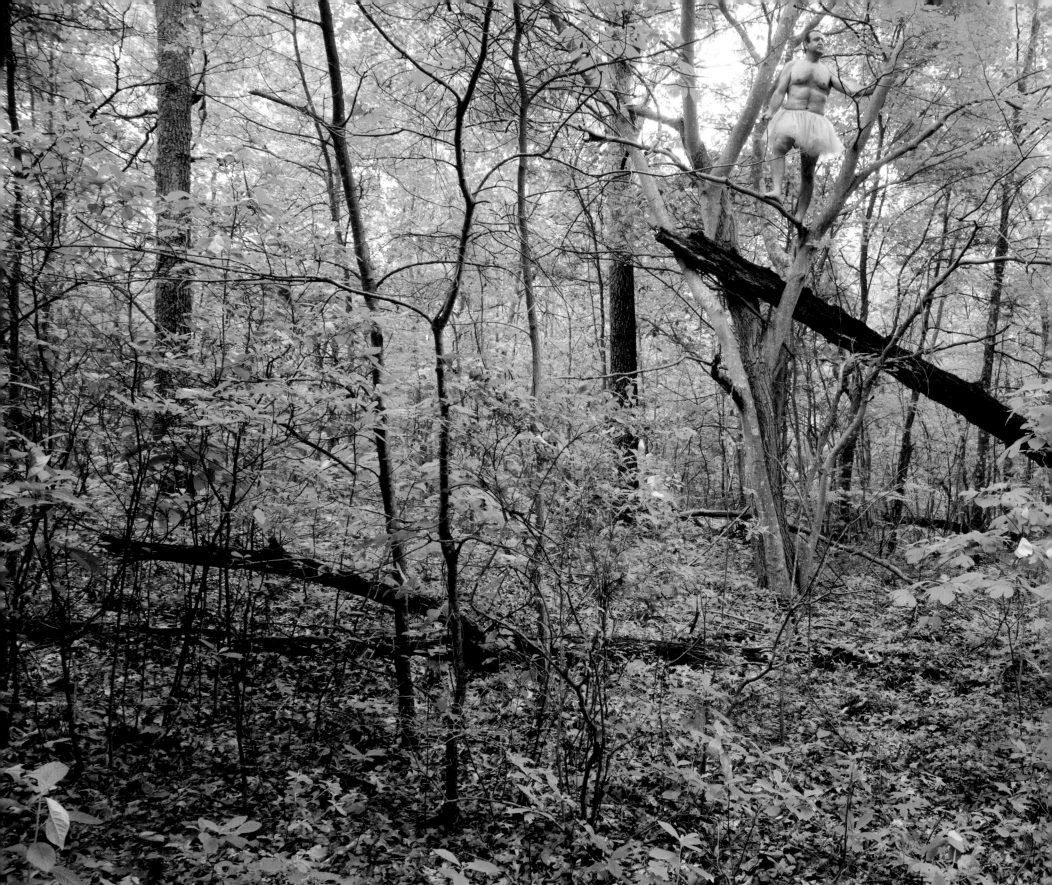

FALLEN TREE LONG ISLAND, NEW YORK 2009

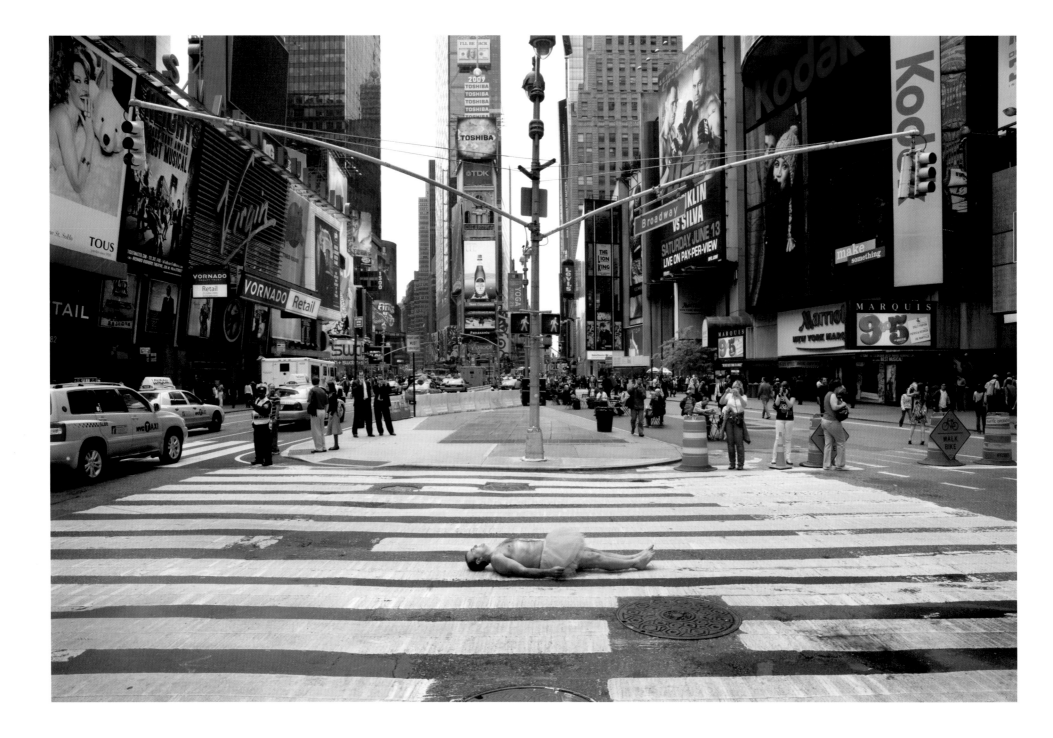

TIMES SQUARE NEW YORK, NEW YORK 2009

COWS RIVERSIDE COUNTY, CALIFORNIA 2005

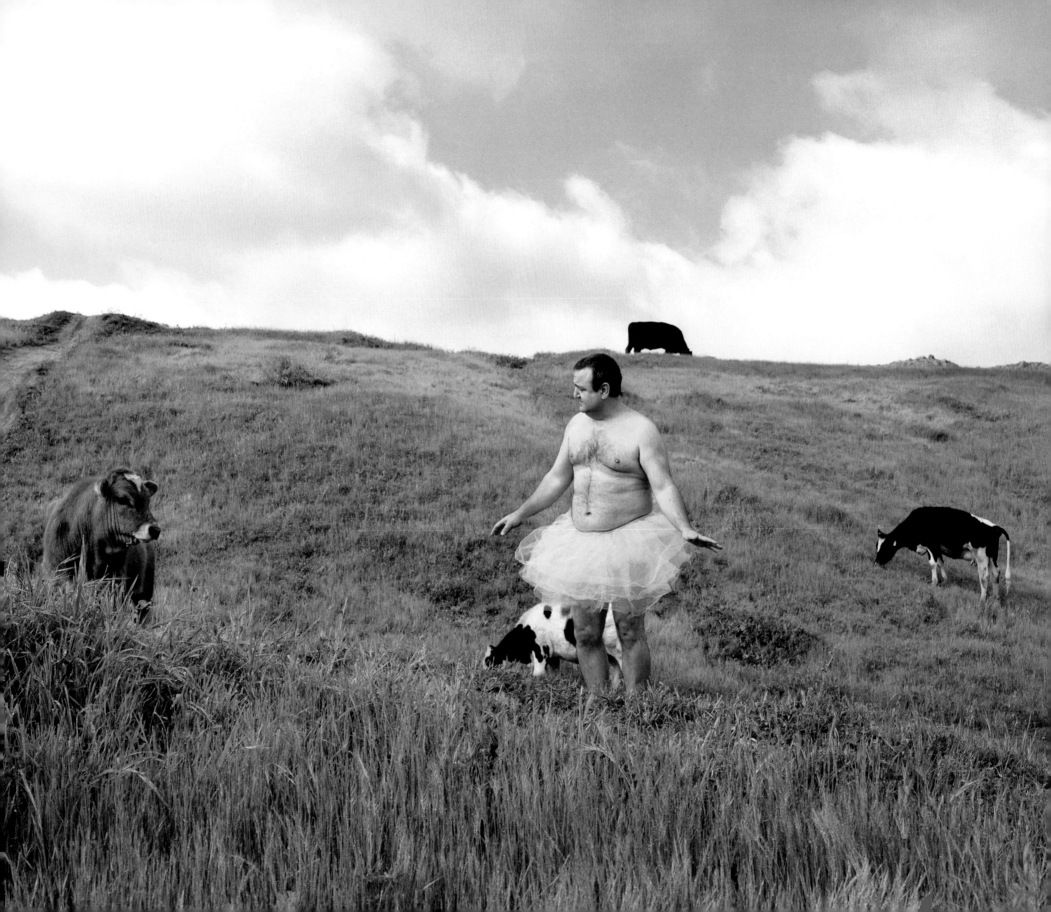

REDWOODS UKIAH, CALIFORNIA 2010

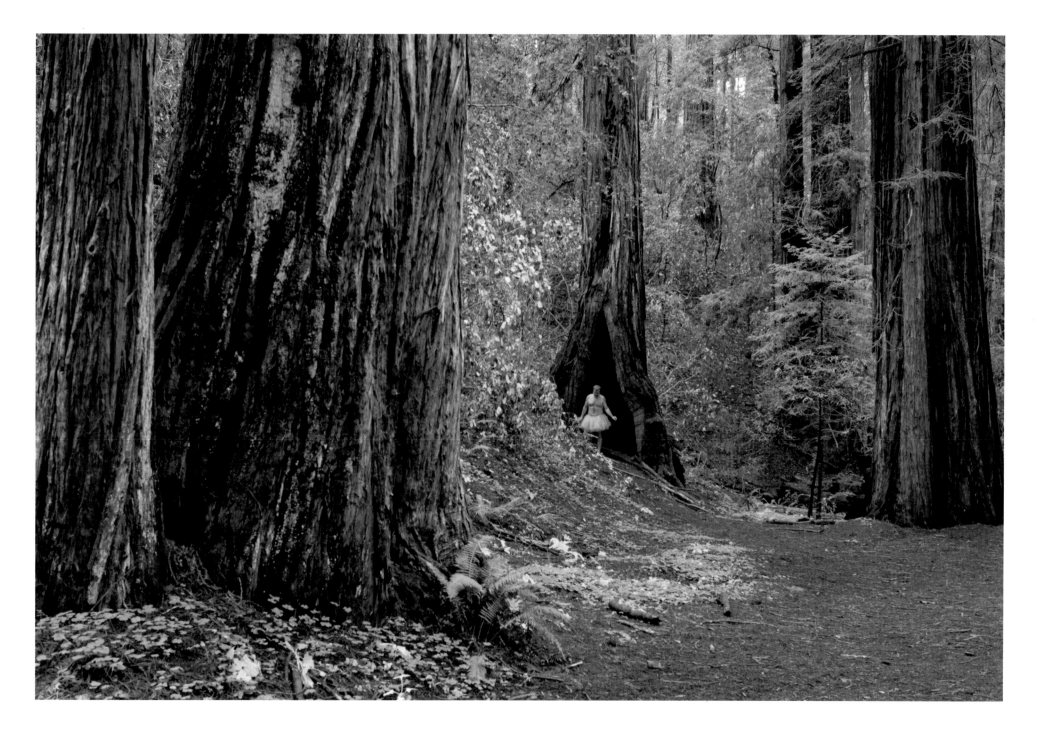

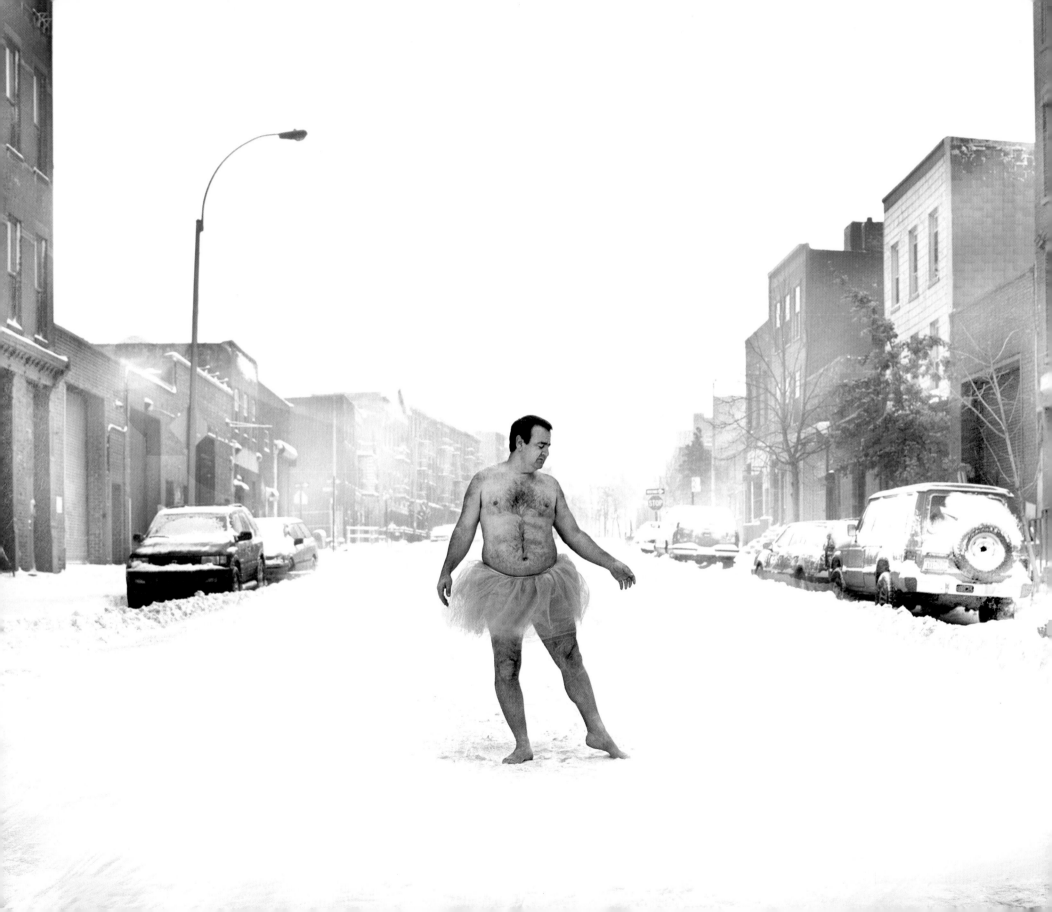

SNOW BROOKLYN, NEW YORK 2003

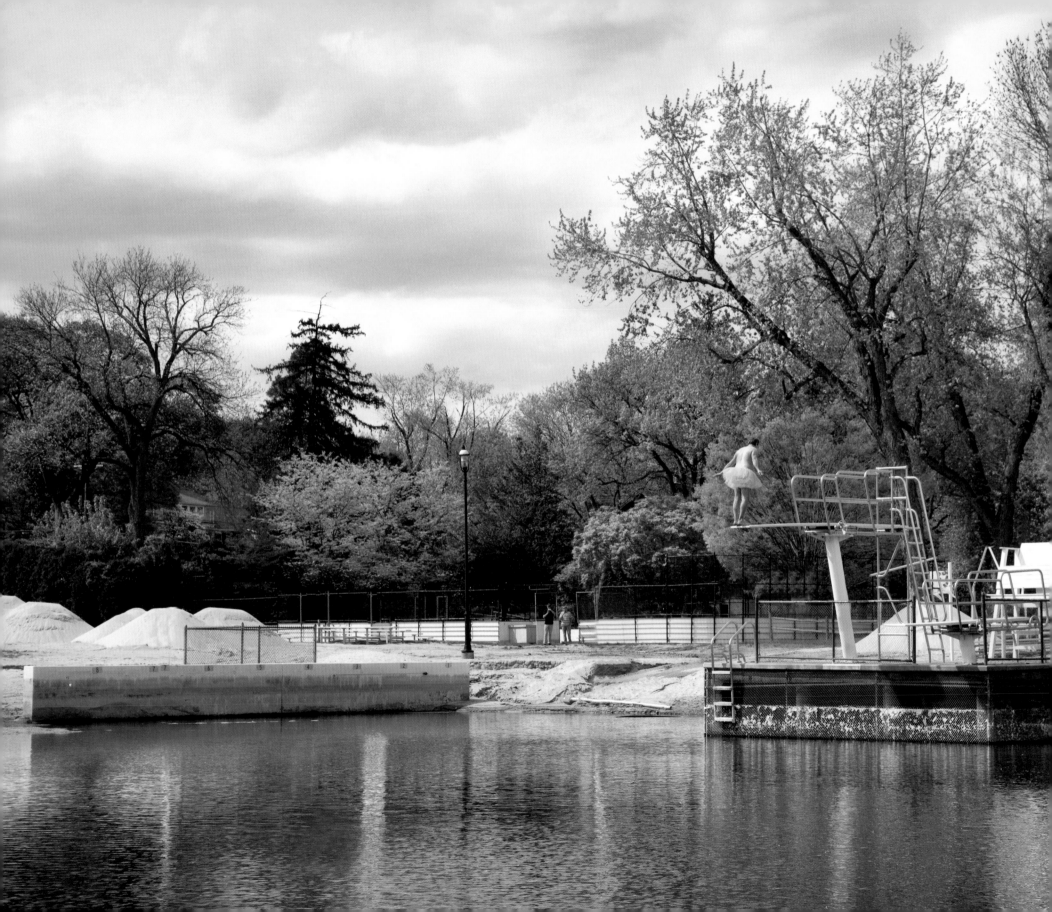

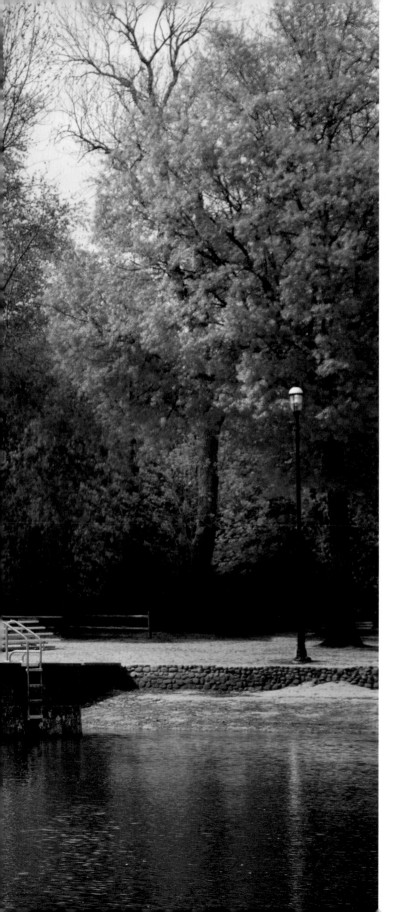

DIVING BOARD RIDGEWOOD, NEW JERSEY 2012

FLAG NEW YORK, NEW YORK 2012

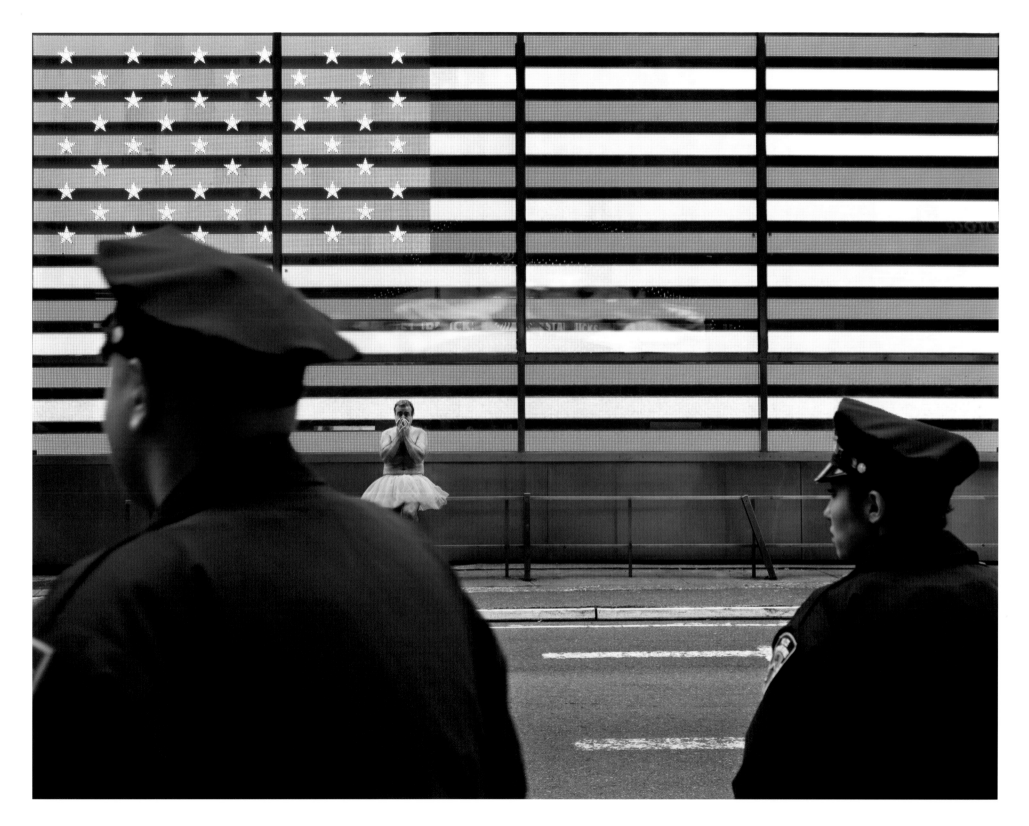

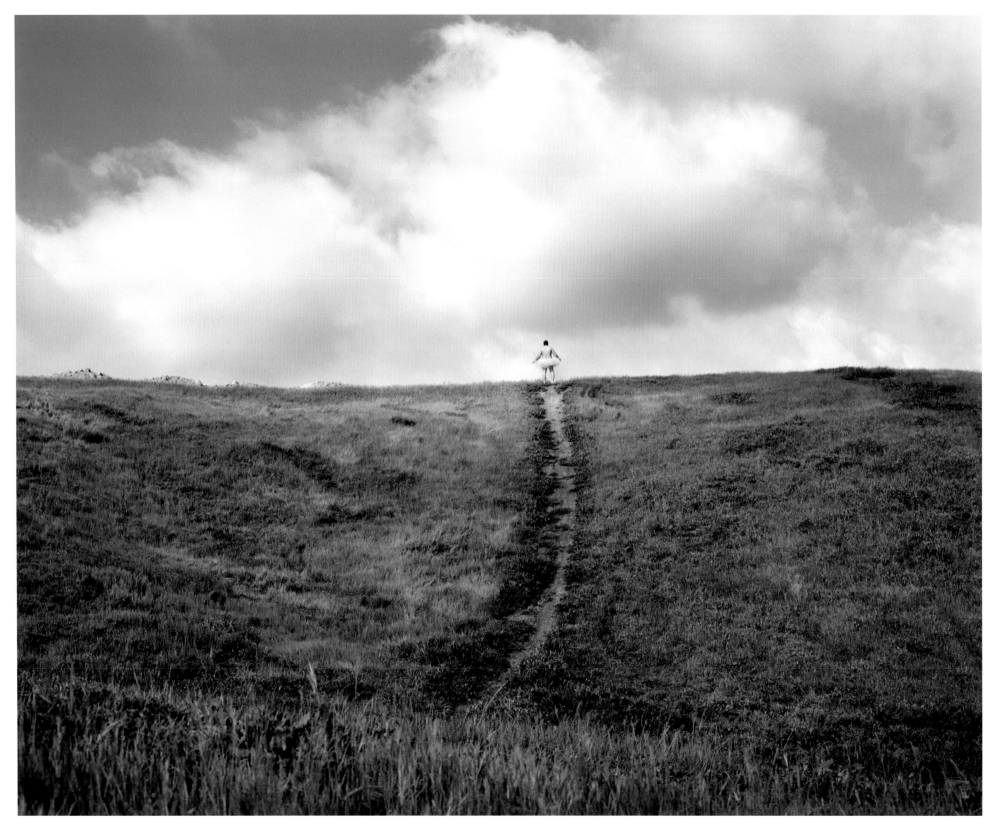

HILLTOP RIVERSIDE COUNTY, CALIFORNIA 2005

ROCK WALL GRAND RAPIDS, MICHIGAN 2011

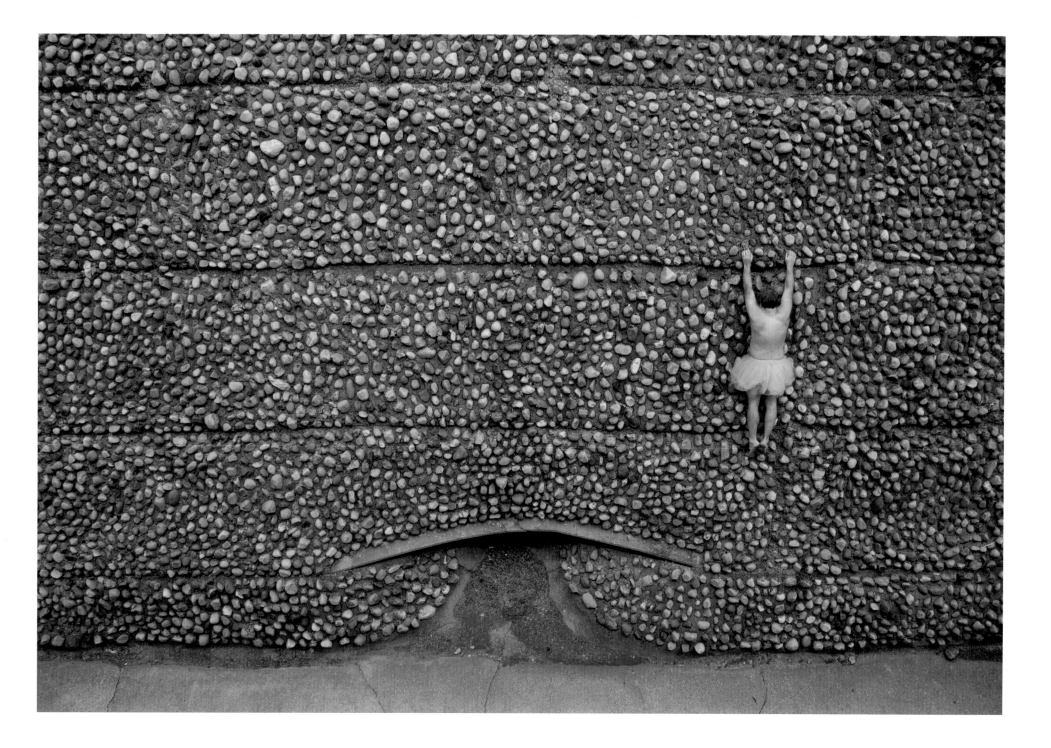

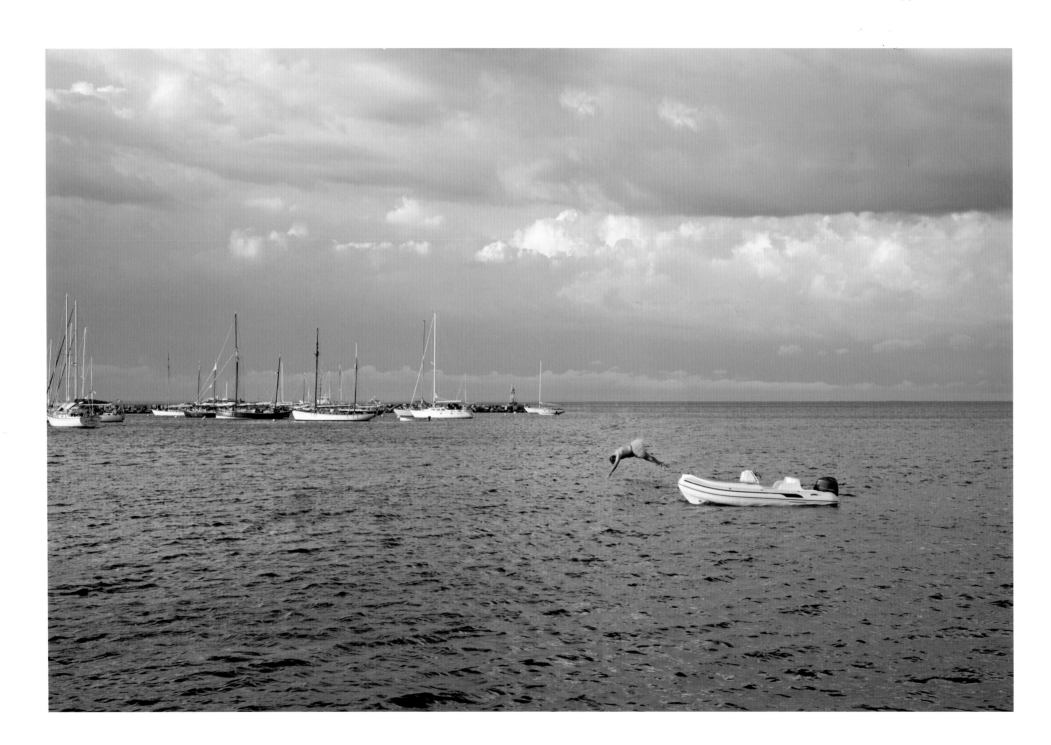

LITTLE BOAT MARTHA'S VINEYARD, MASSACHUSETTS 2012

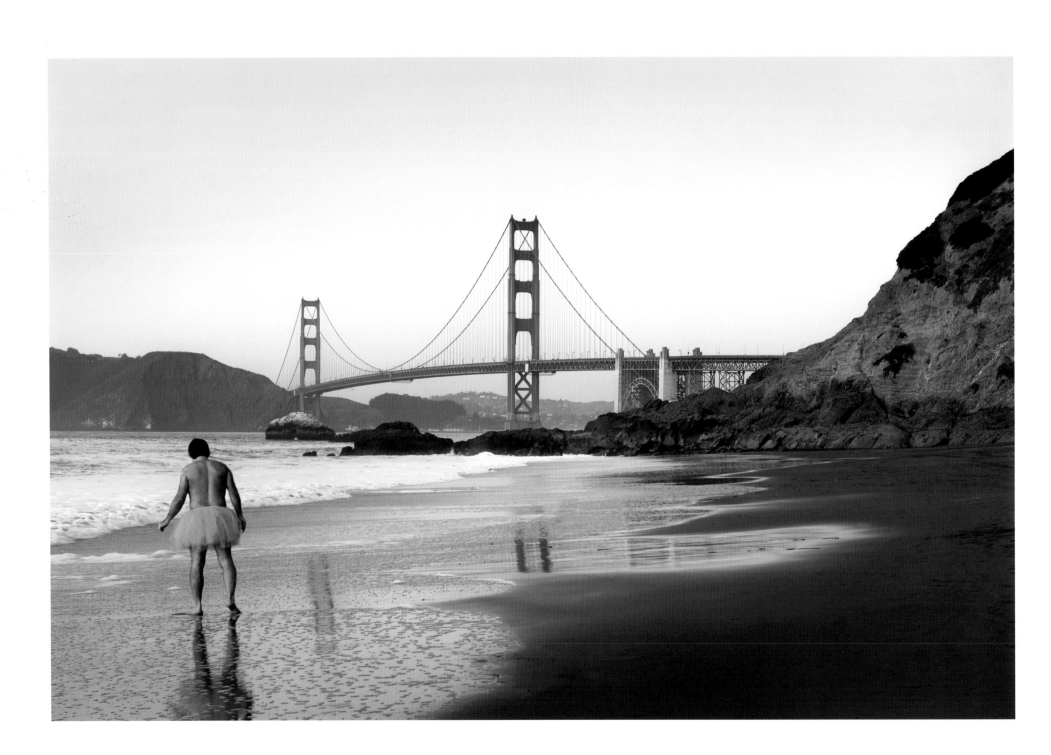

GOLDEN GATE BRIDGE SAN FRANCISCO, CALIFORNIA 2010

JUMP LONG ISLAND, NEW YORK 2012

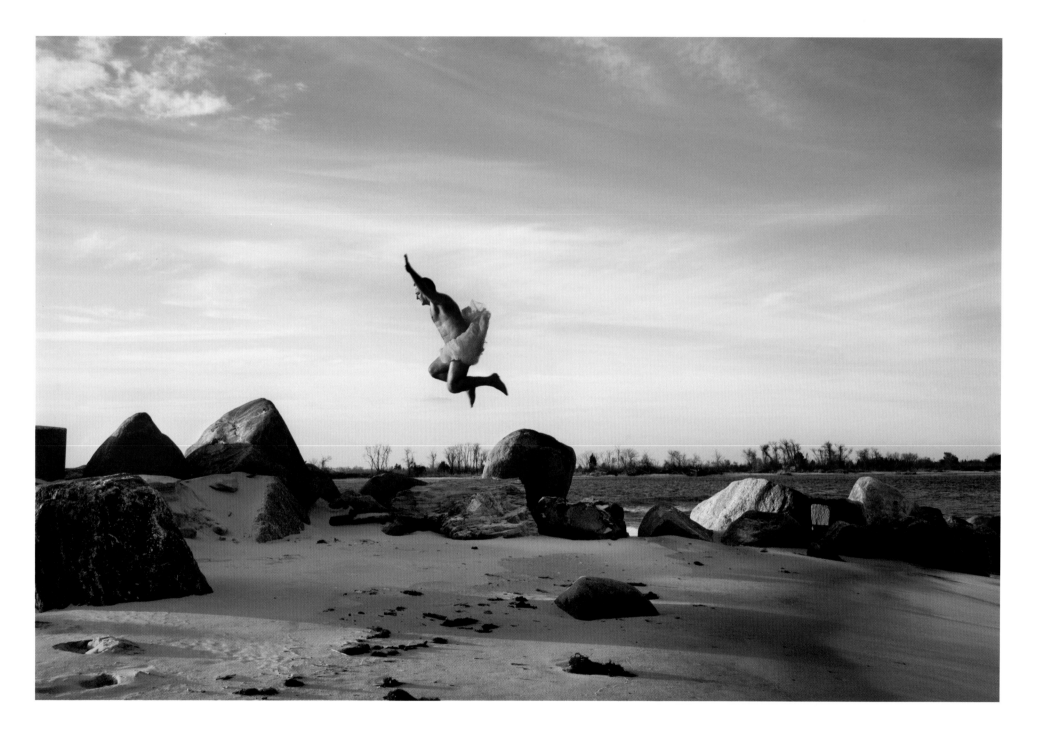

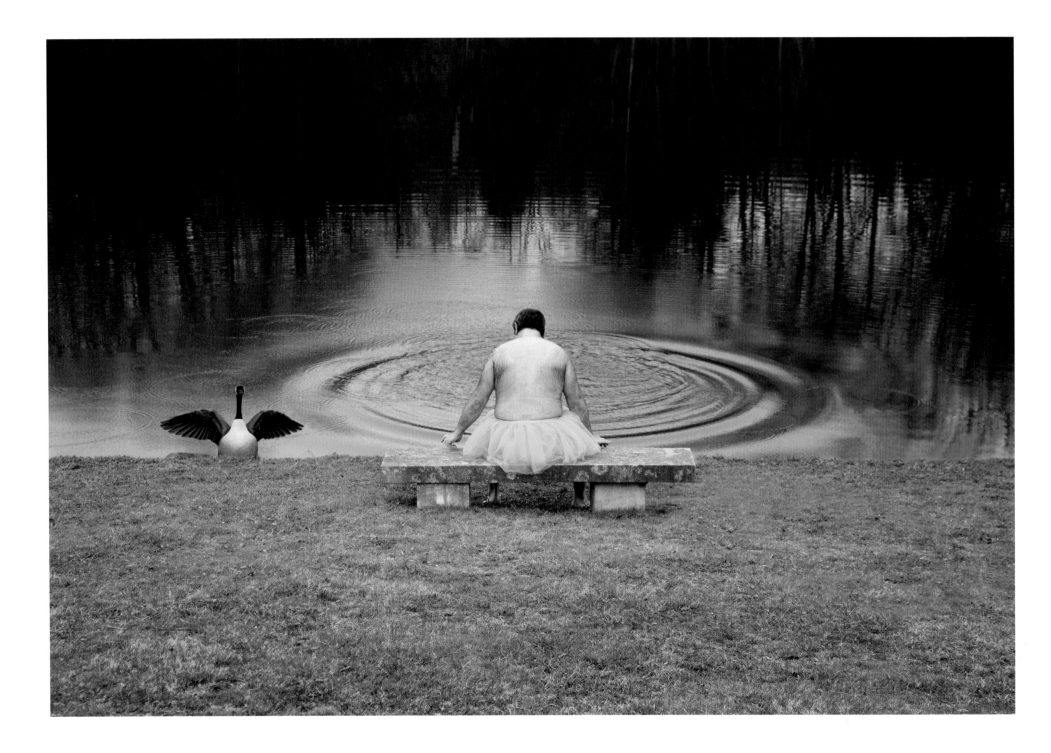

GOOSE SADDLE RIVER, NEW JERSEY 2012

HARVEST GAYLORD, MICHIGAN 2004

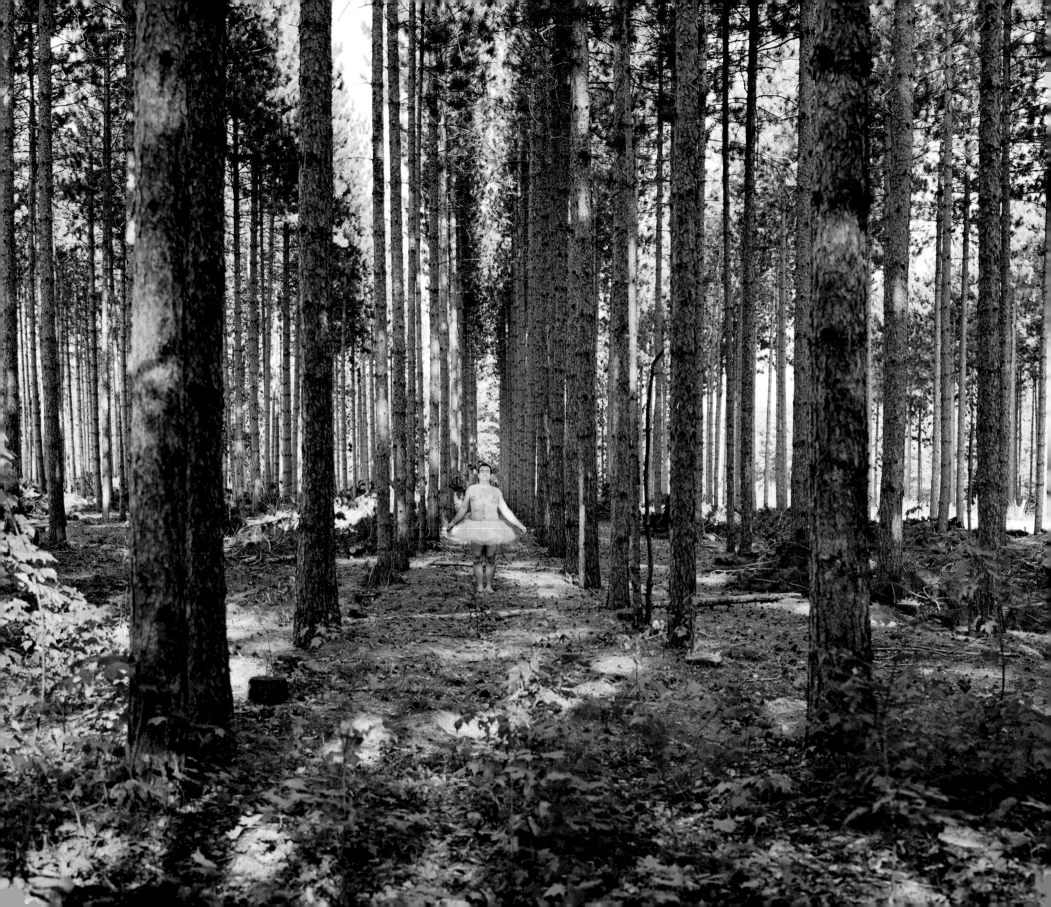

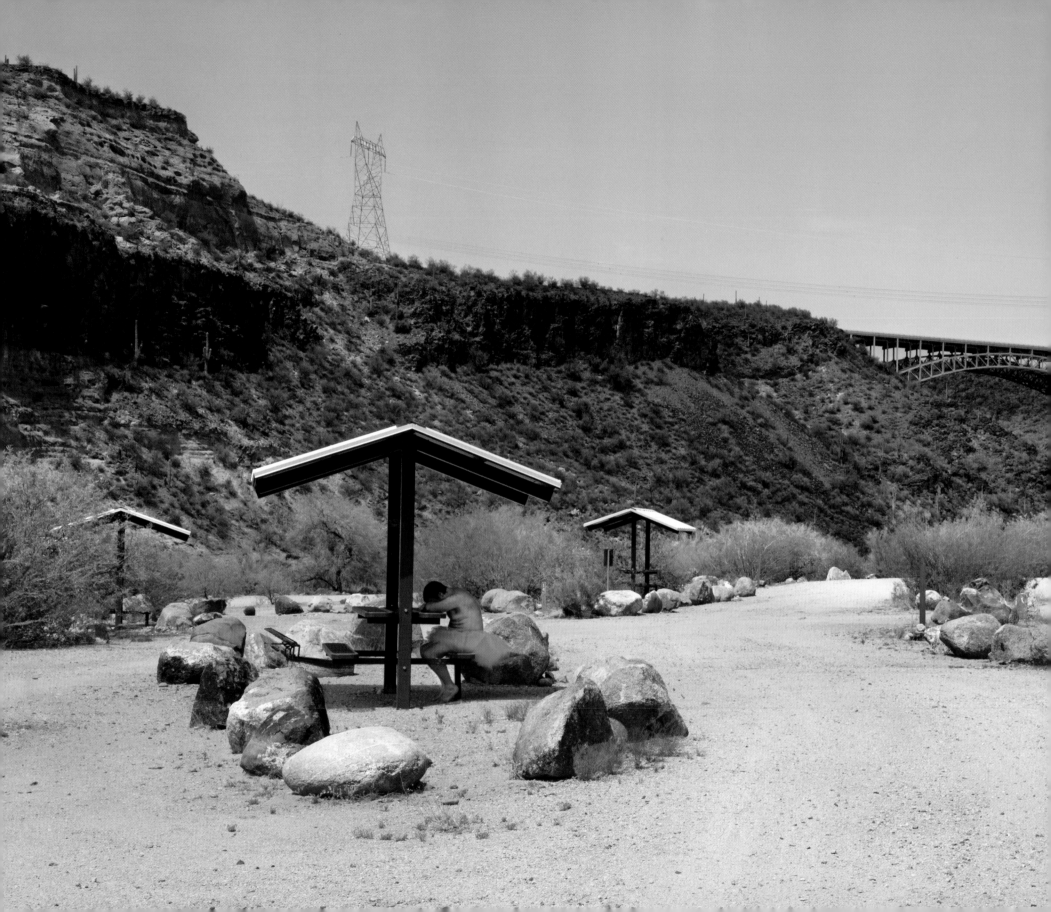

RAMADA I-93, ARIZONA 2008

BOAT DOCK ROCKAWAY, NEW YORK 2008

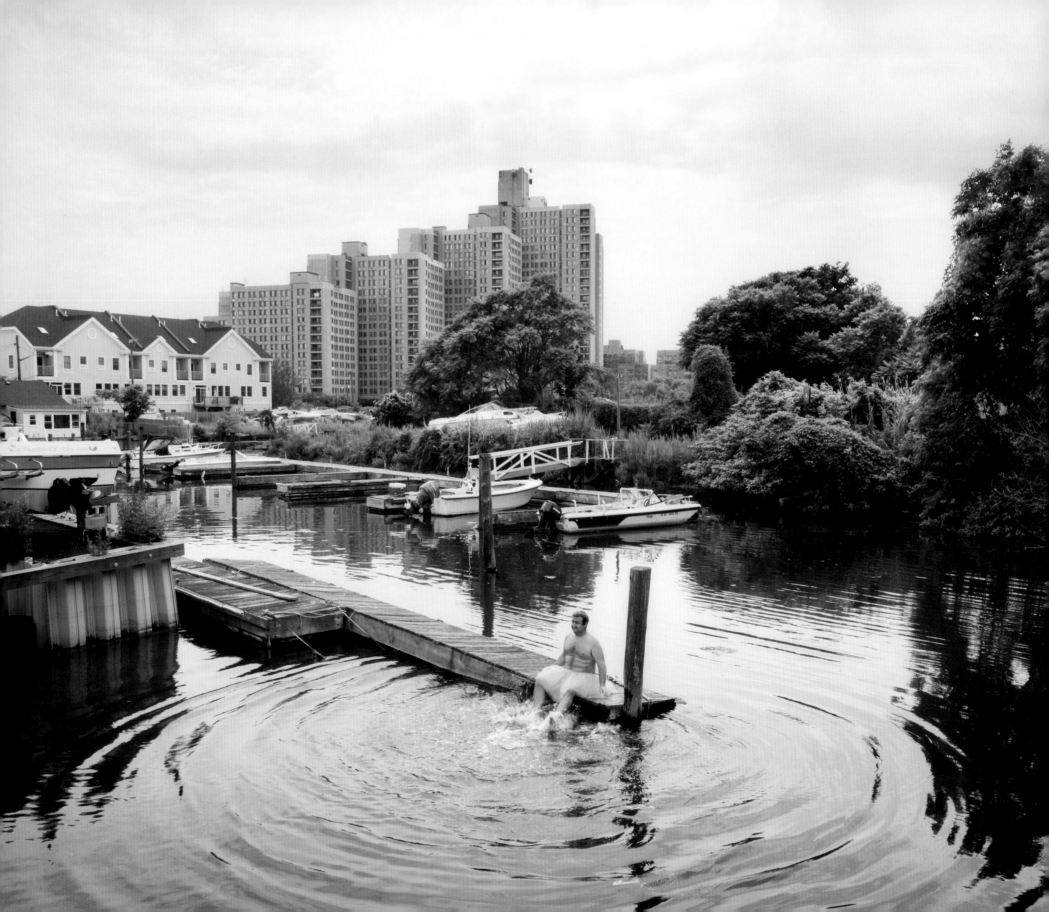

GAZEBO FRANKENMUTH, MICHIGAN 2008

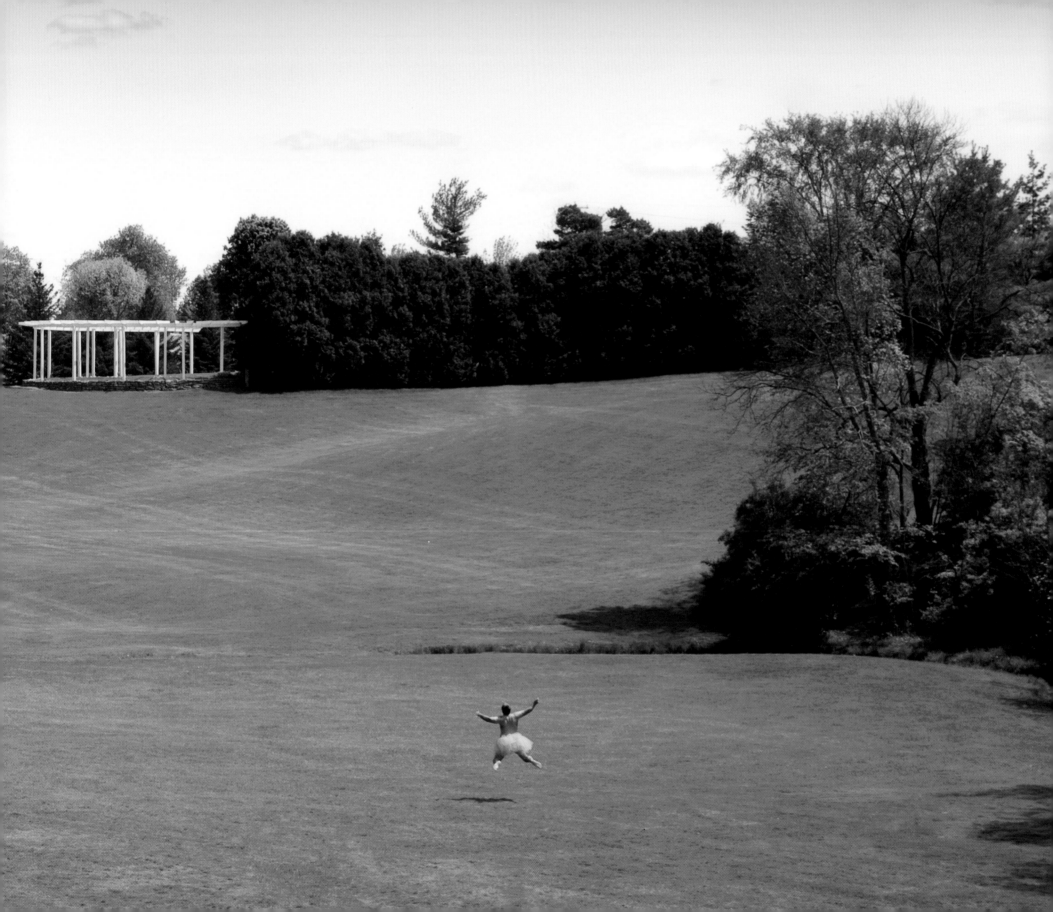

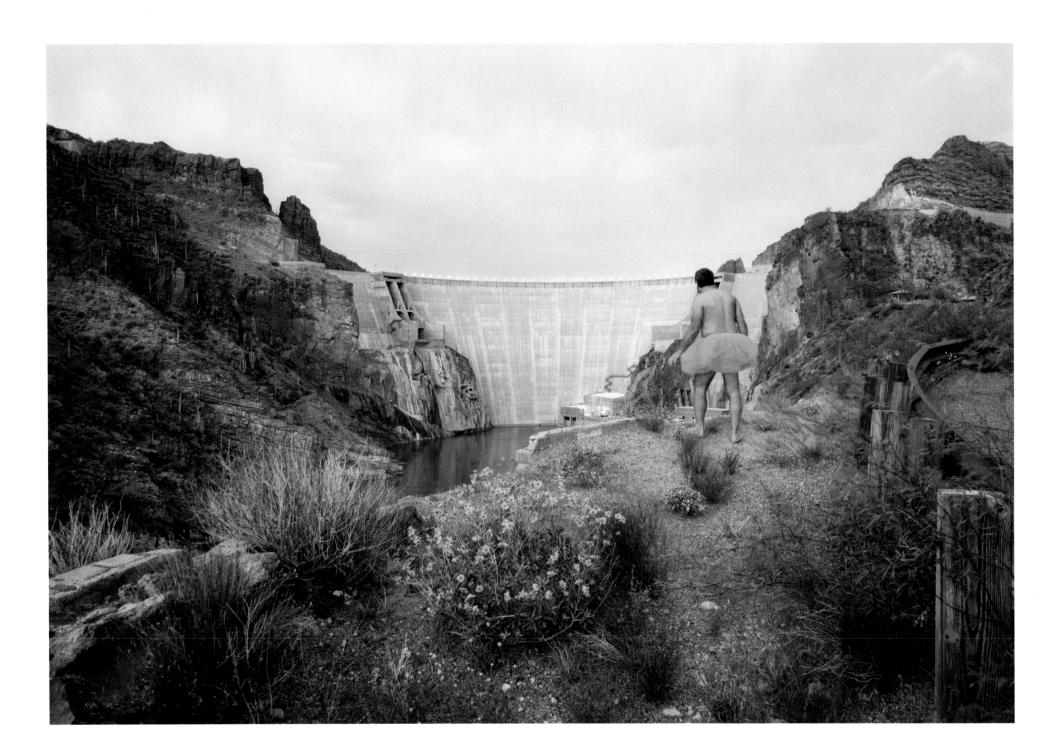

DAM ROOSEVELT LAKE, ARIZONA 2012

MOTOR HOME PRIMM, NEVADA 2008

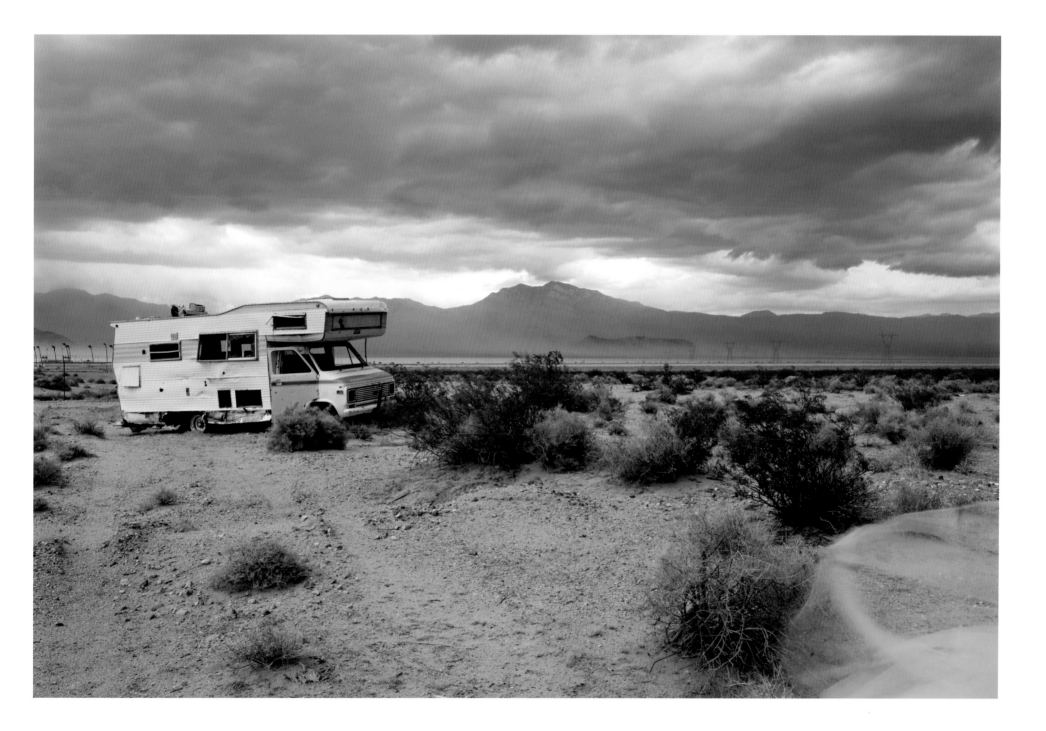

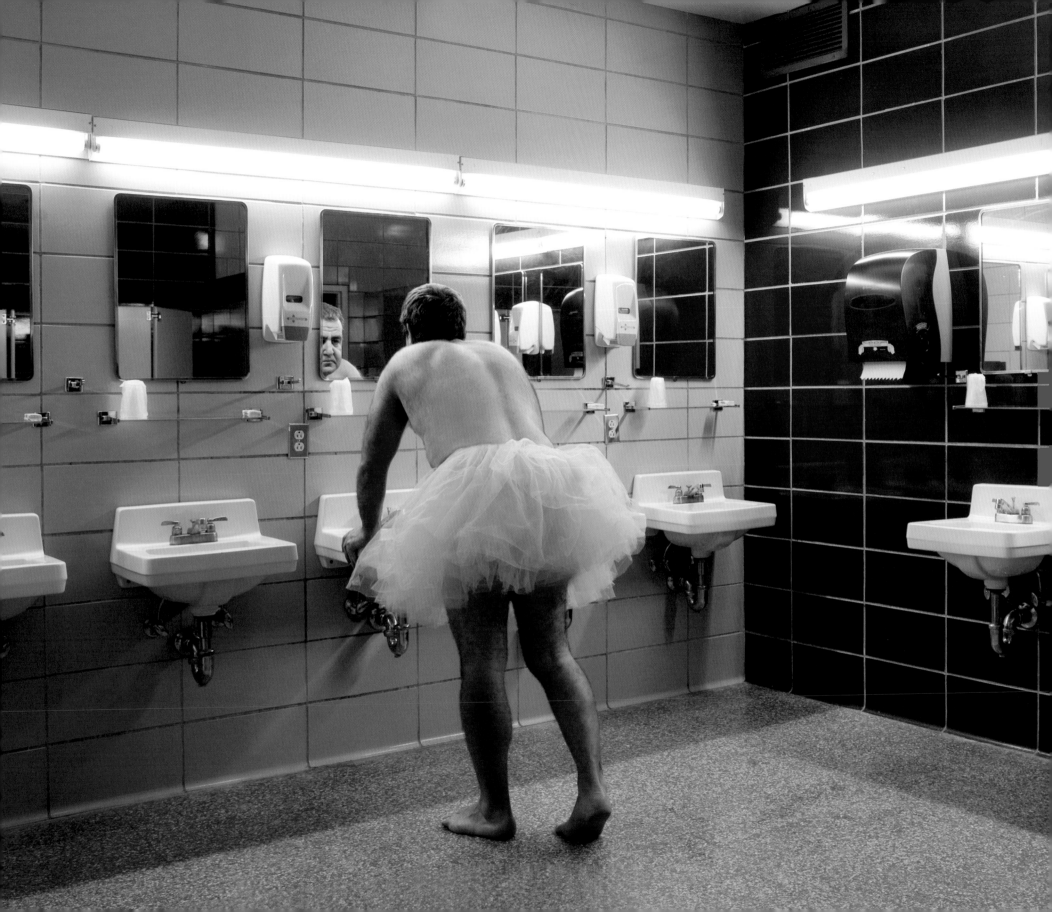

RESTROOM SANTA FE, NEW MEXICO 2009

BLUE PALMS WILDWOOD, NEW JERSEY 2008

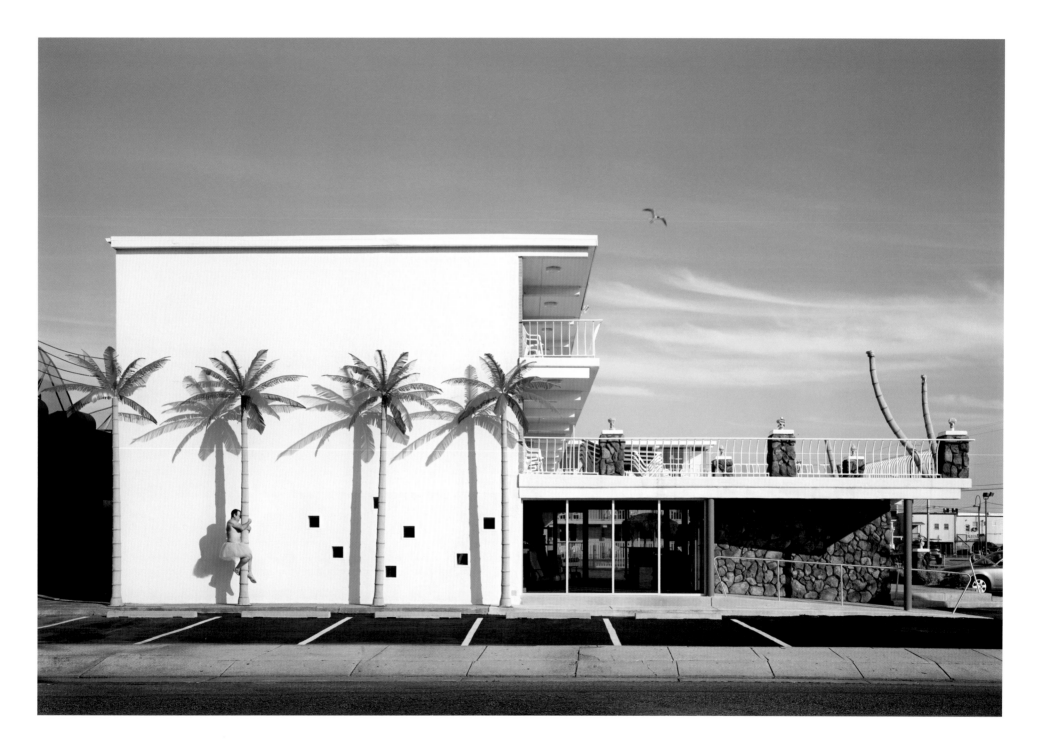

PULASKI SKYWAY NEWARK, NEW JERSEY 2008

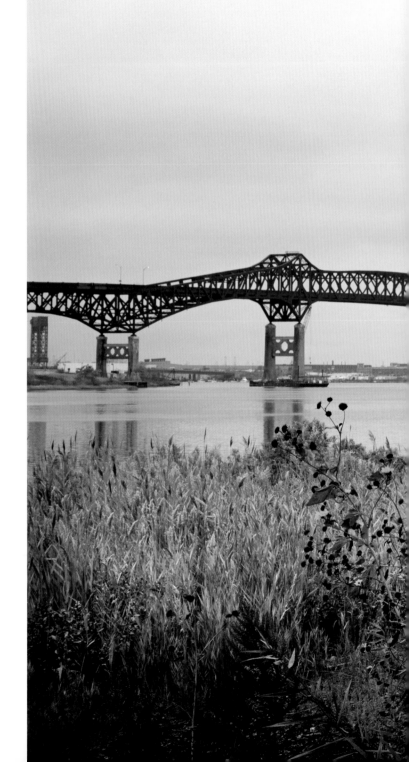

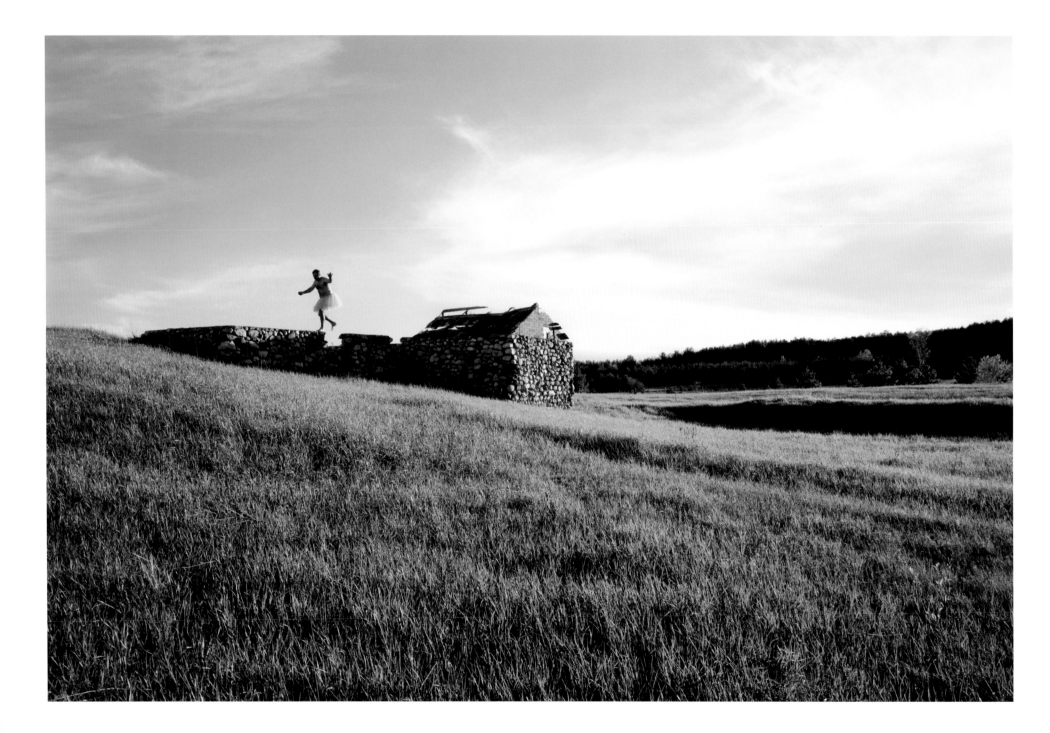

ROCK HOUSE ELMIRA, MICHIGAN 2008

BRIDGE PHOENIX, ARIZONA 2012

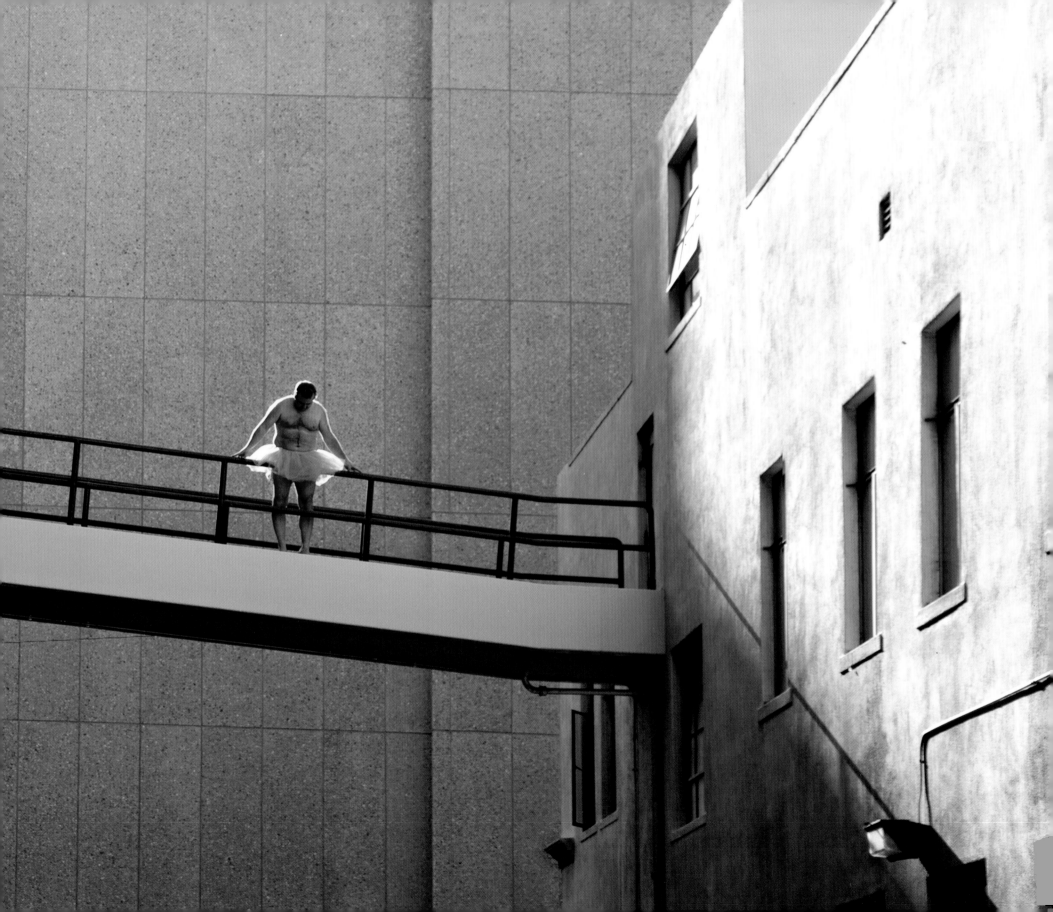

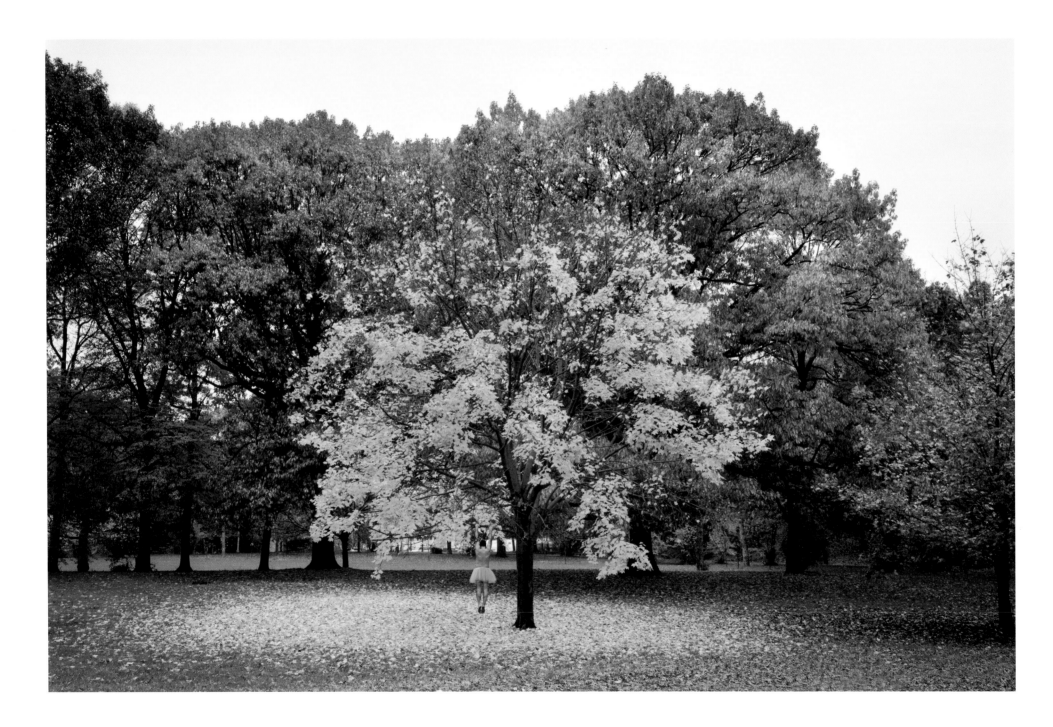

AUTUMN TREE NEWARK, NEW JERSEY 2008

HIGH DESERT ROAD MONUMENT VALLEY, UTAH 2009

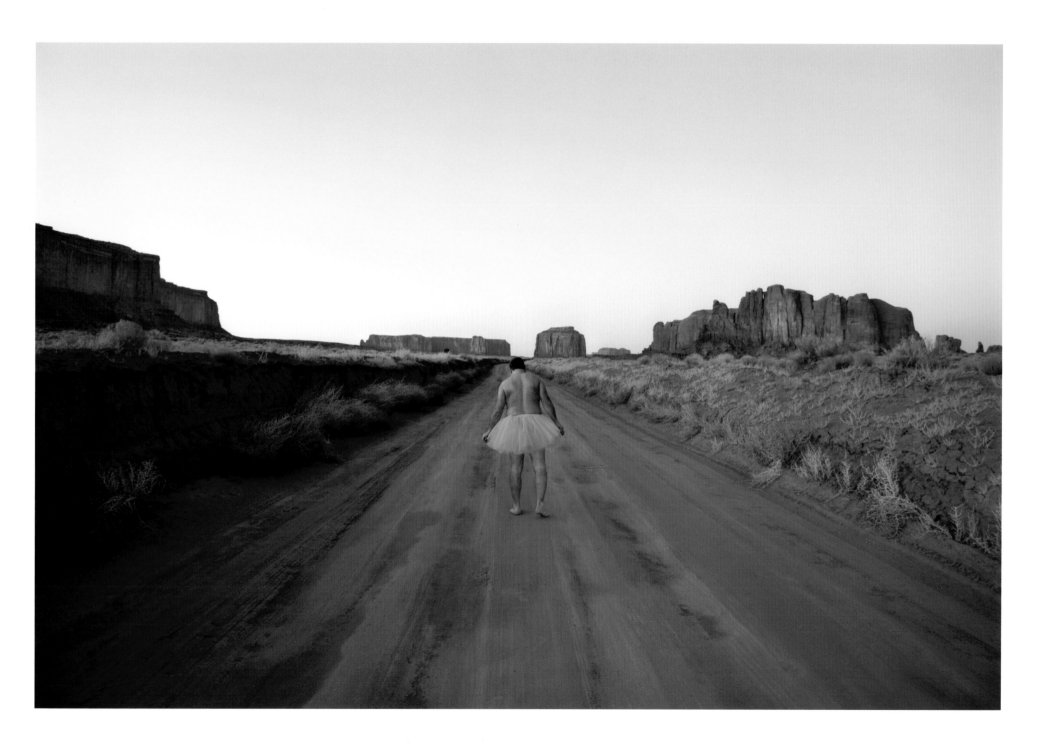

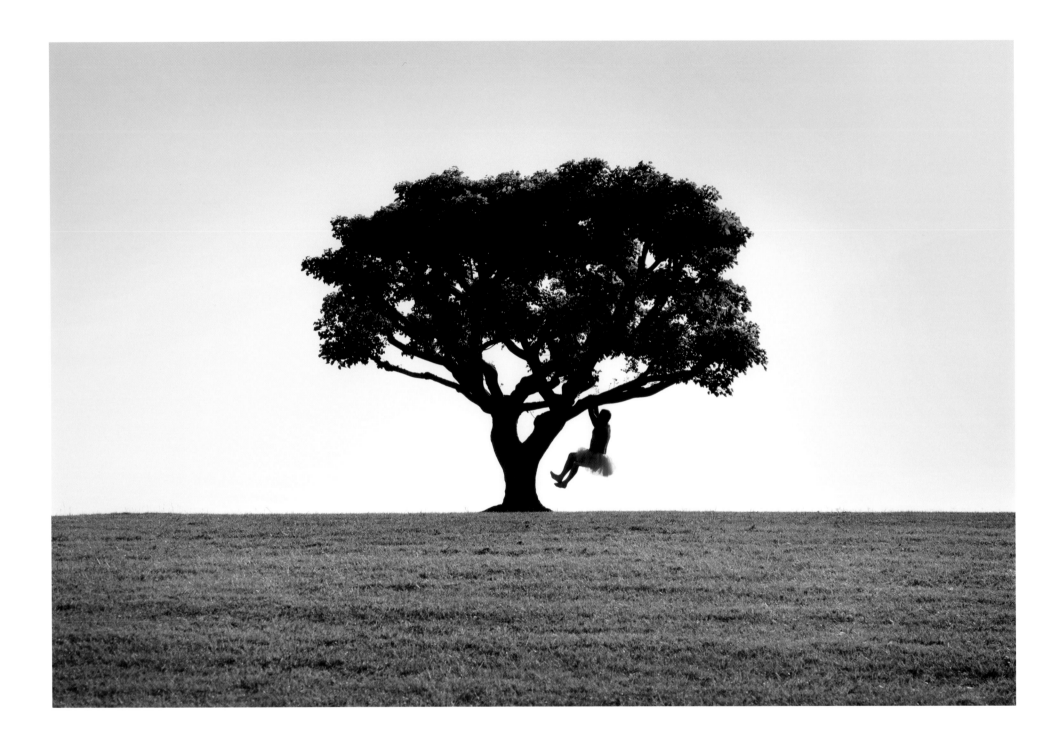

MALIBU TREE MALIBU, CALIFORNIA 2009

FAME WILDWOOD, NEW JERSEY 2008

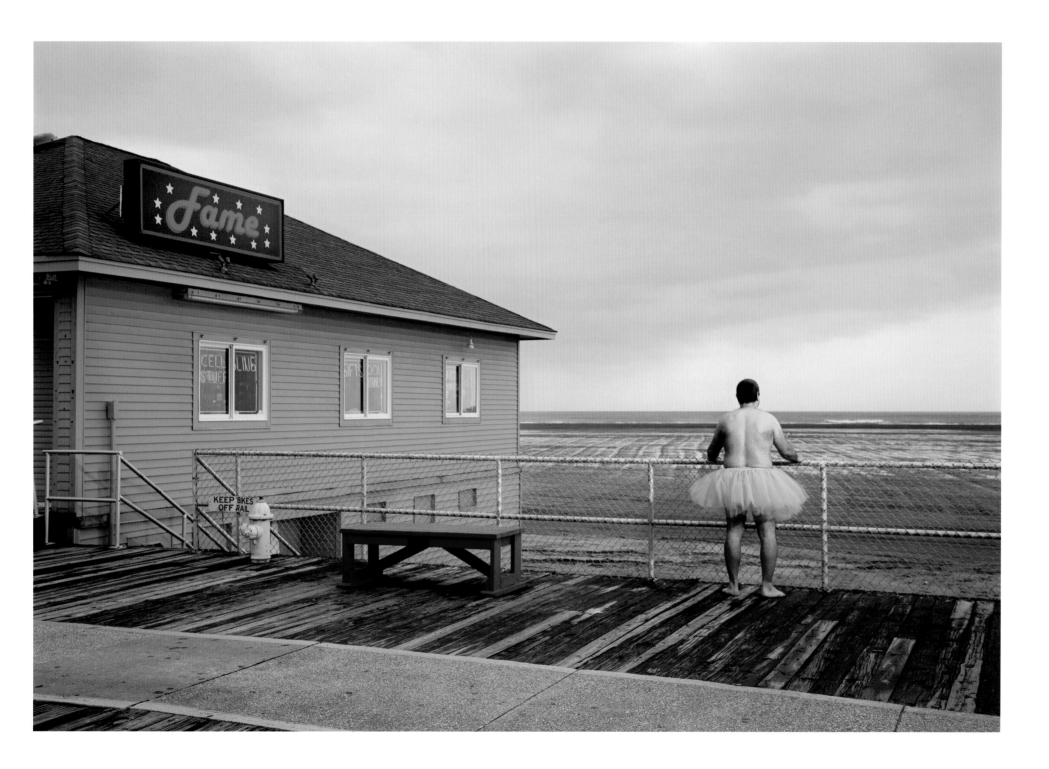

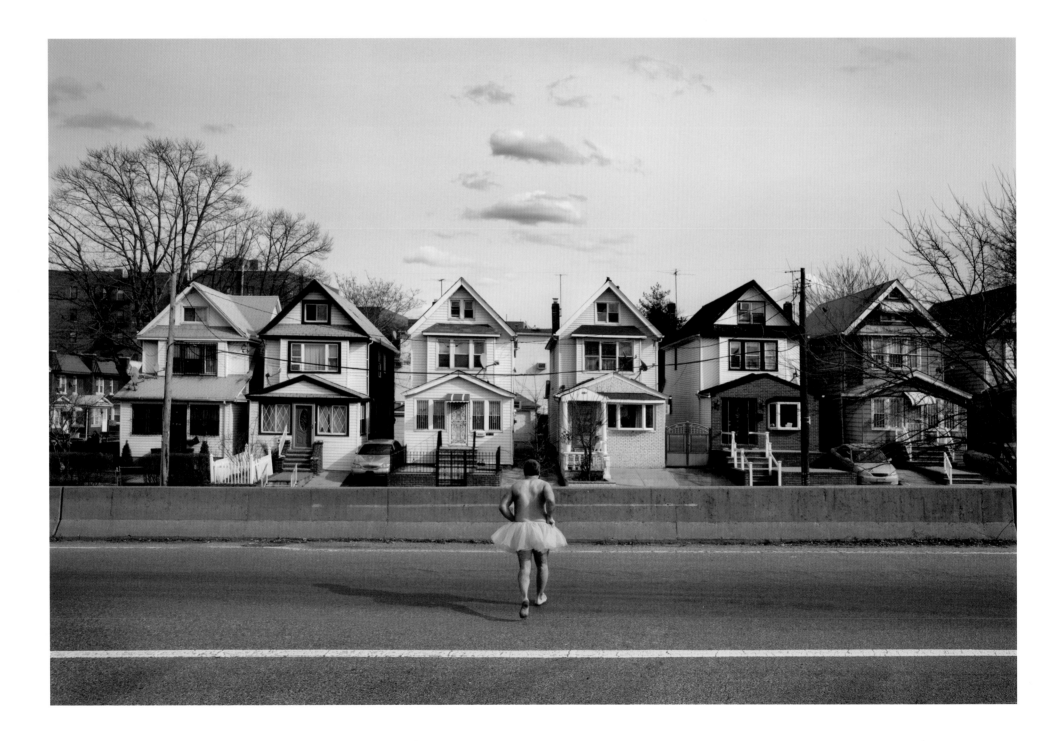

ROW HOUSES QUEENS, NEW YORK 2012

LINCOLN MEMORIAL WASHINGTON D.C. 2012

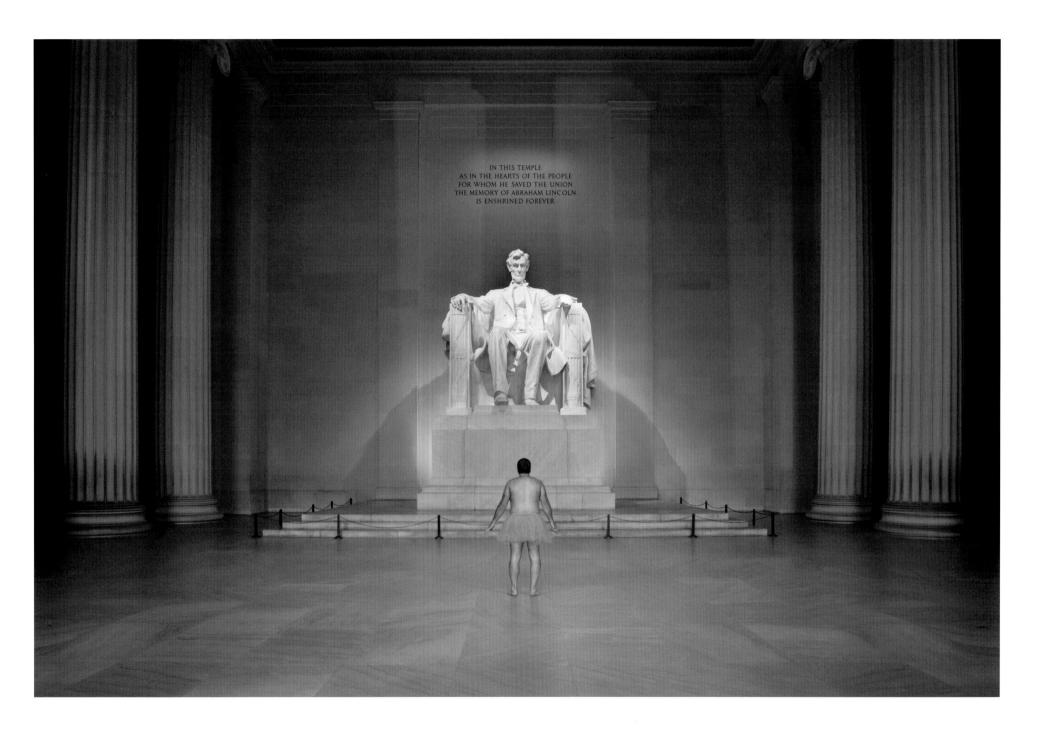

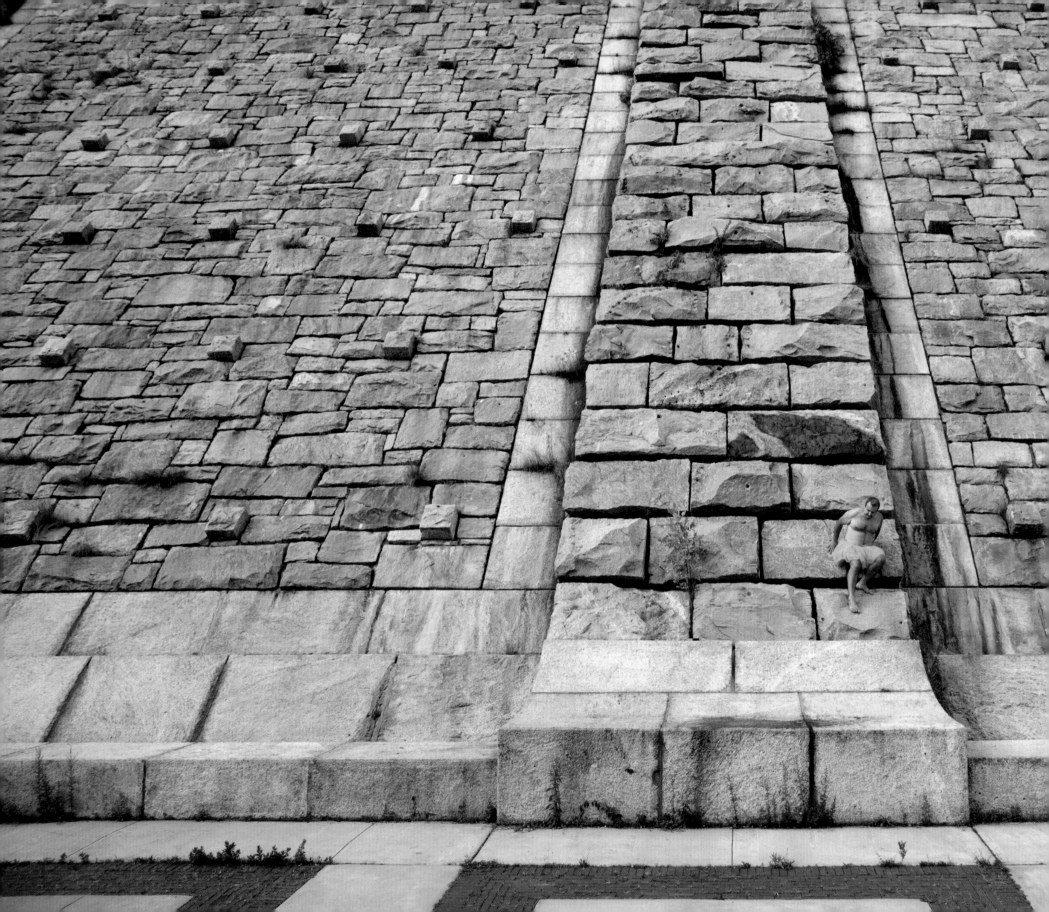

LITTLE TREE VALHALLA, NEW YORK 2012

HORSES ELMIRA, MICHIGAN 2008

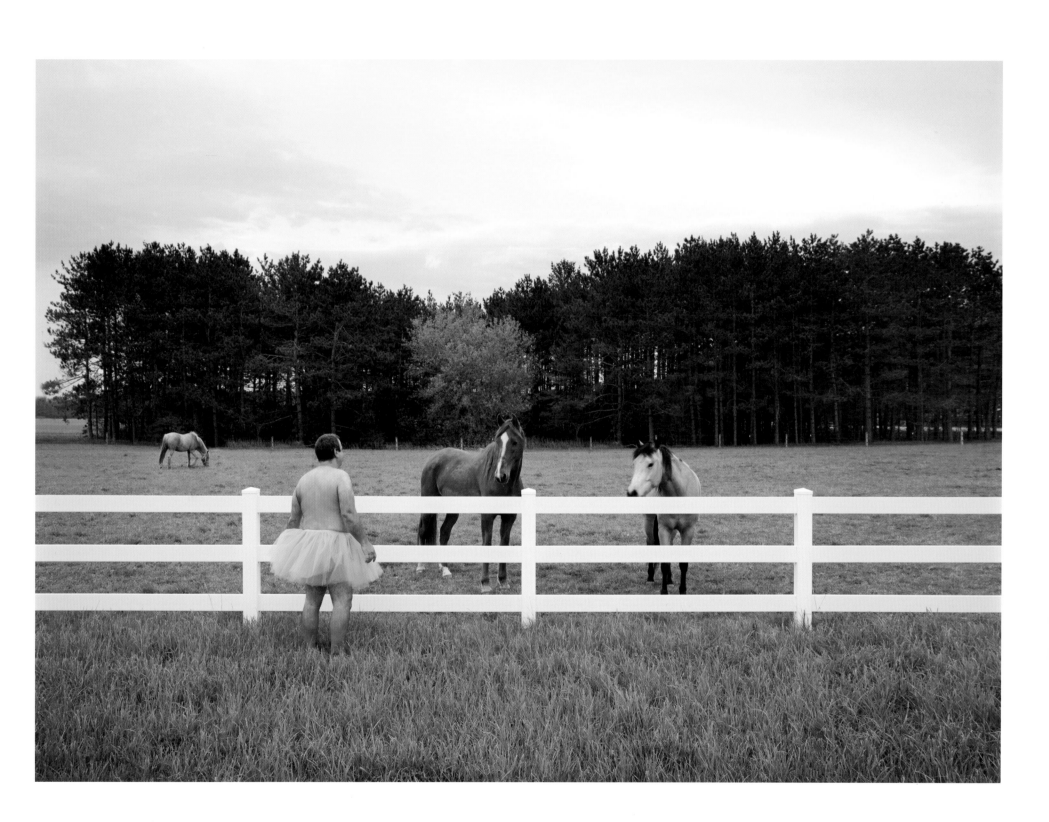

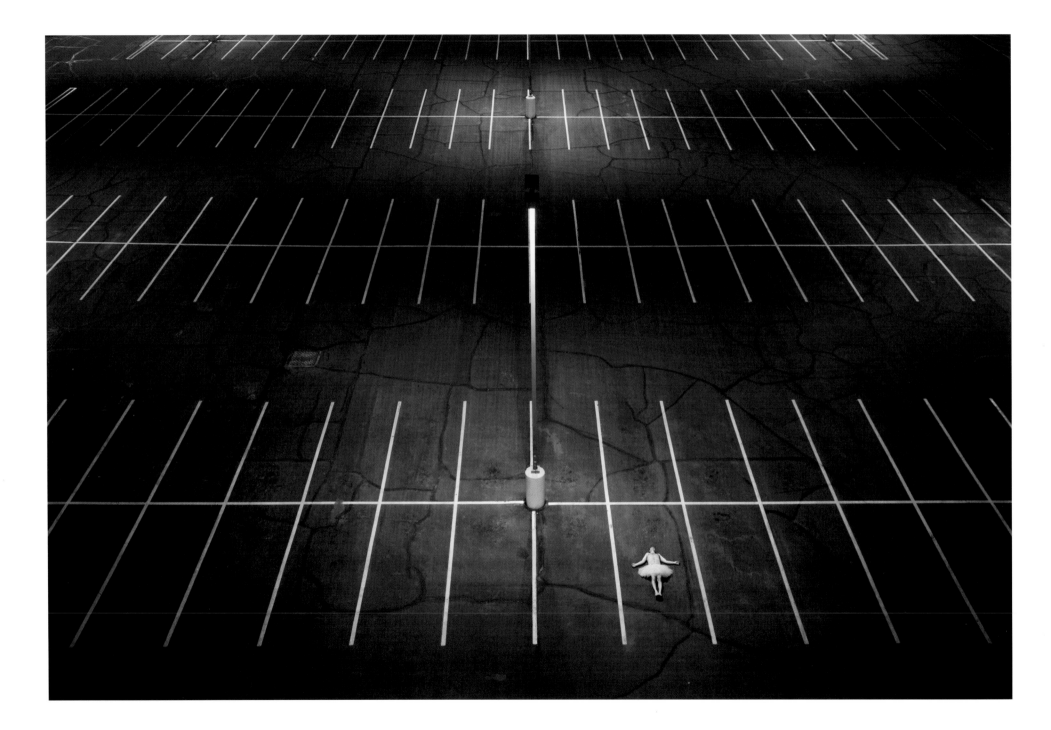

PARKING LOT TEMPE, ARIZONA, 2009

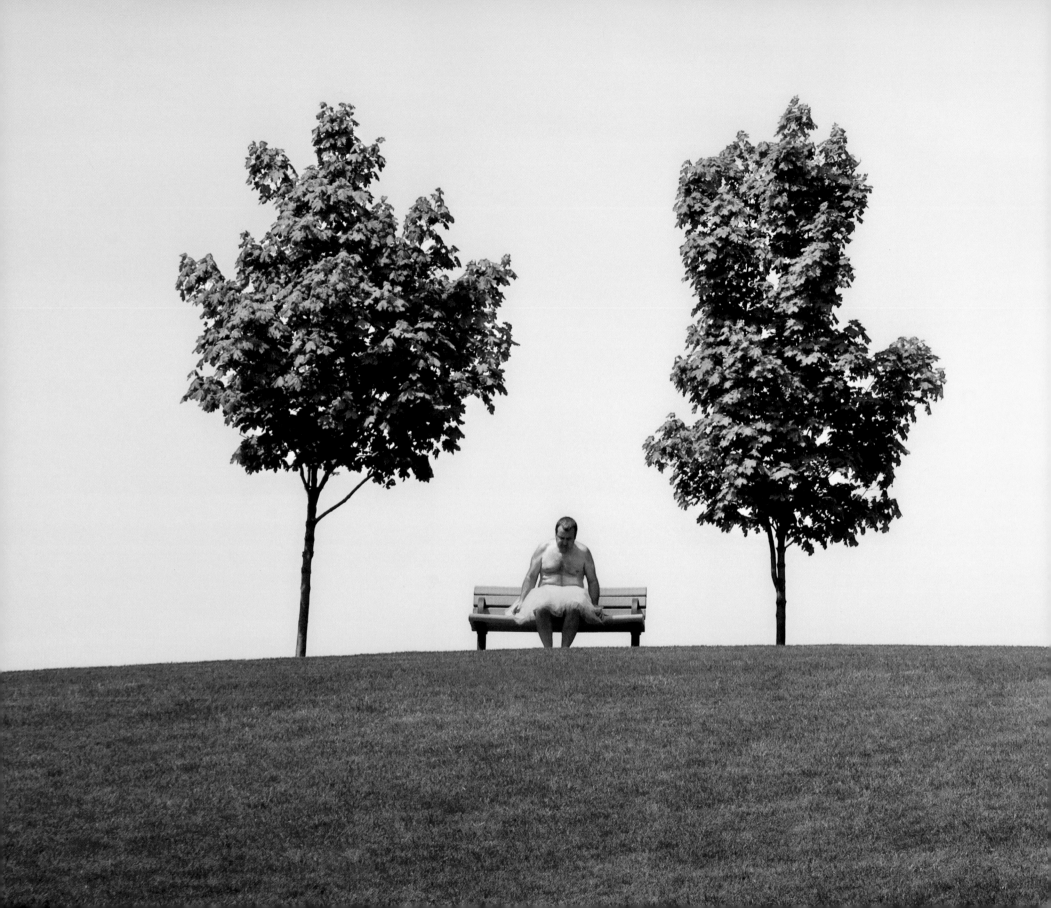

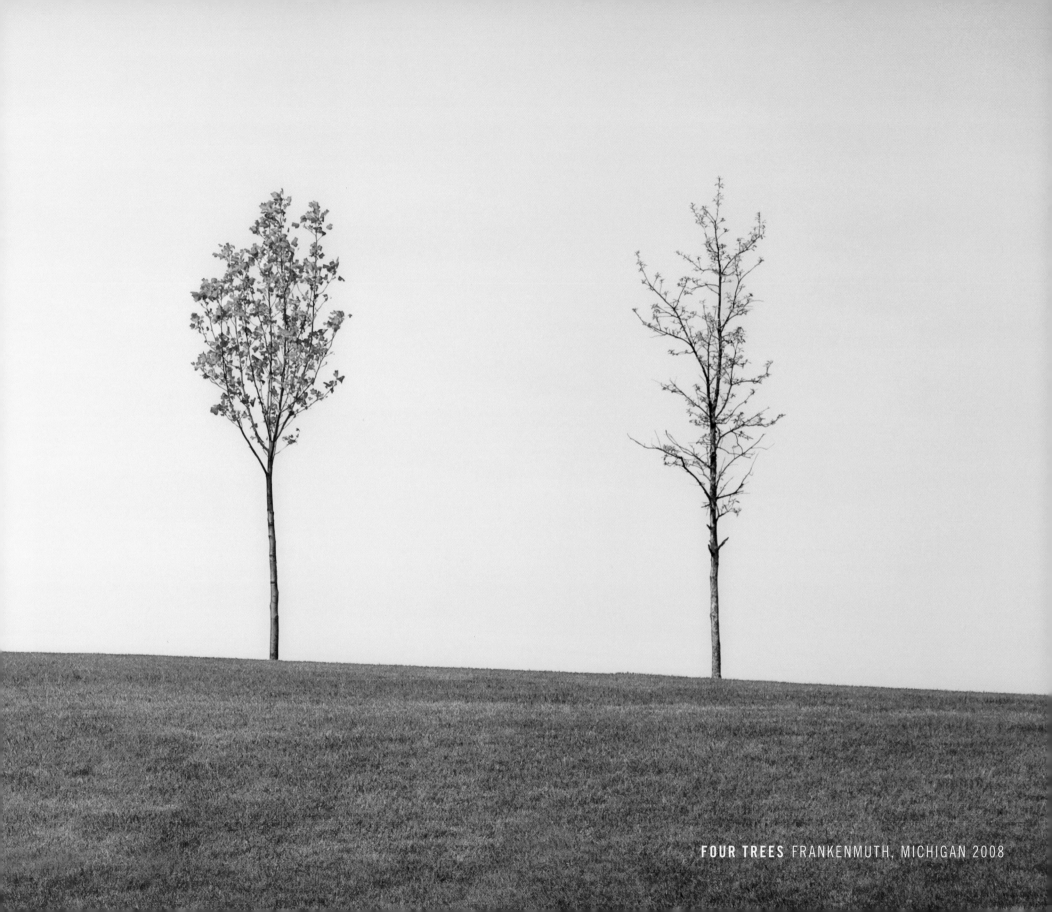

FOUR TREES FRANKENMUTH, MICHIGAN 2008

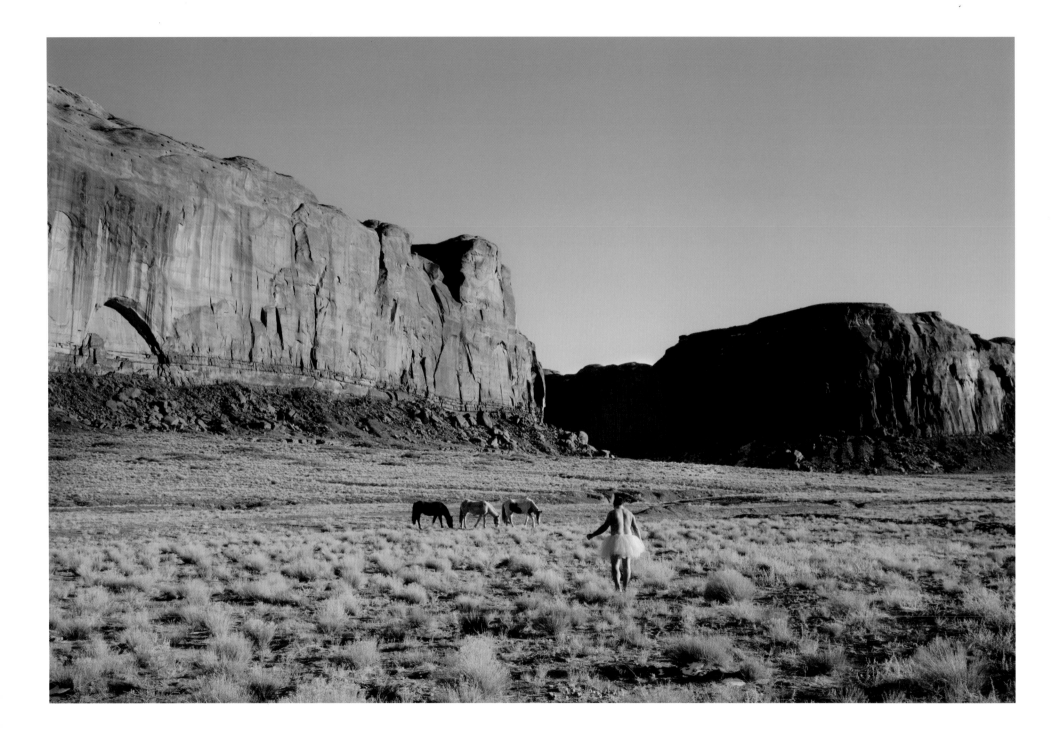

THREE HORSES MONUMENT VALLEY, UTAH 2009

OVERPASS FLUSHING, NEW YORK 2008

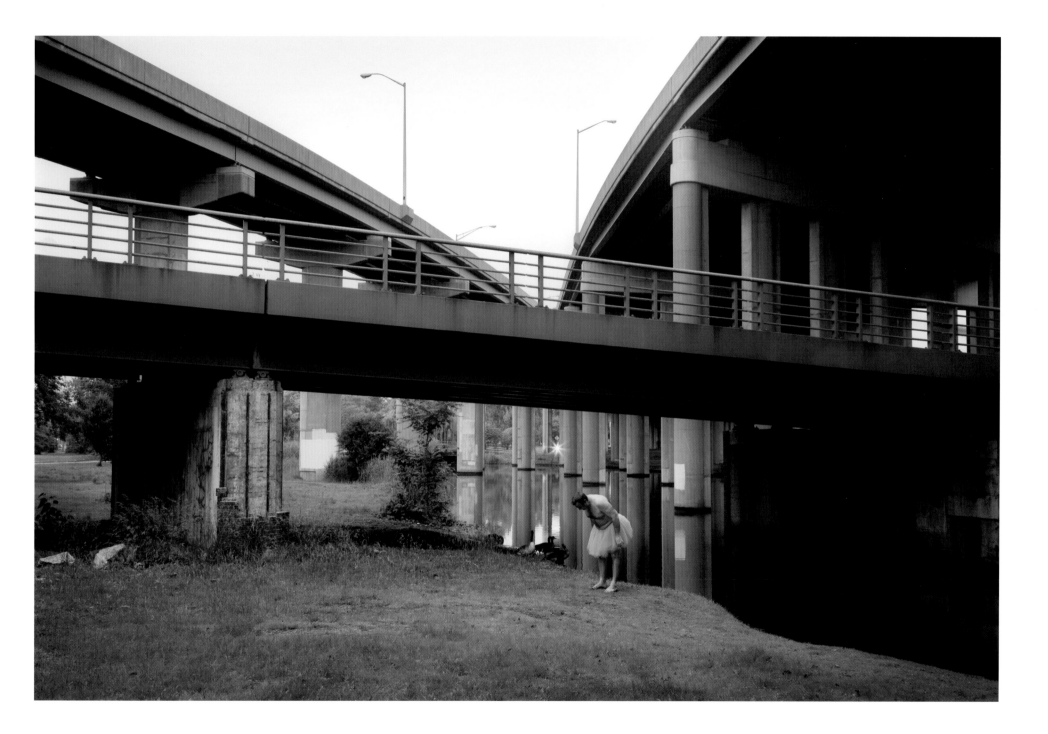

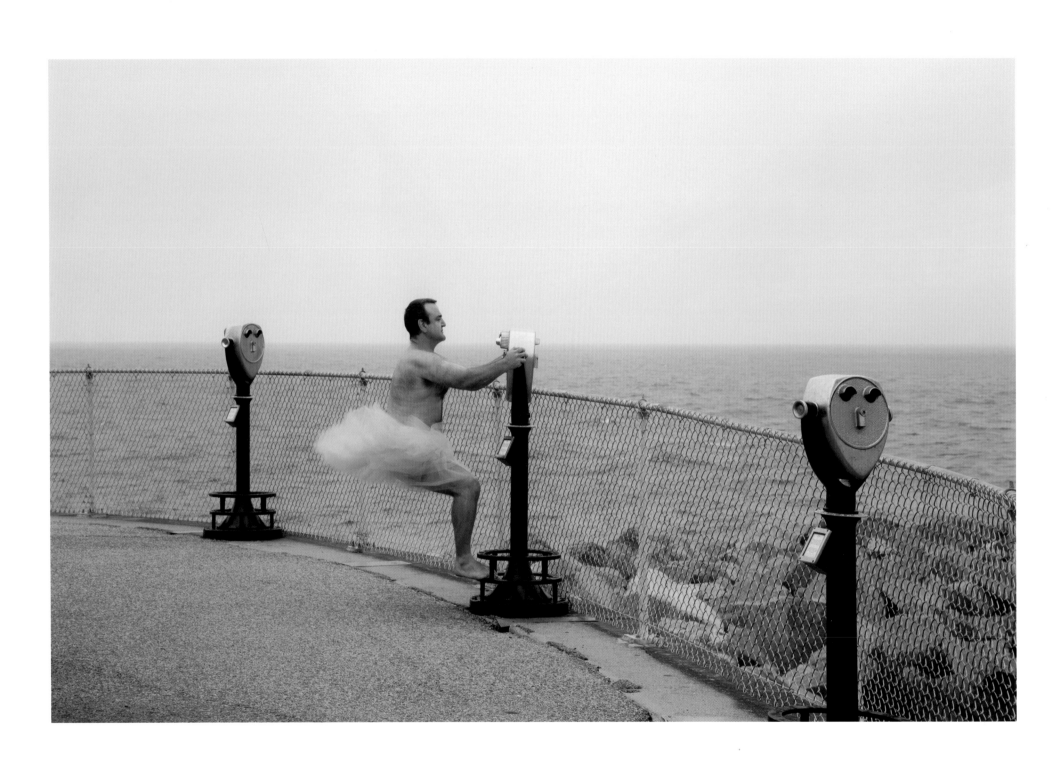

LOOKOUT CHESAPEAKE BAY, VIRGINIA 2008

WATERFALL KAATERSKILL FALLS, NEW YORK 2008

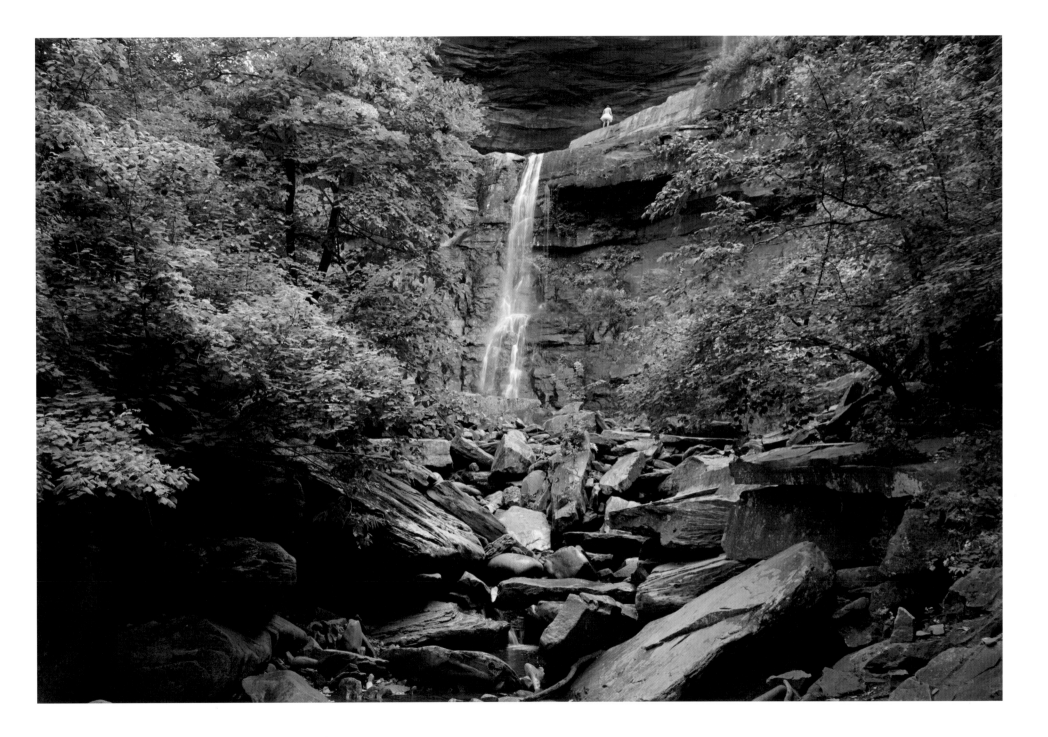

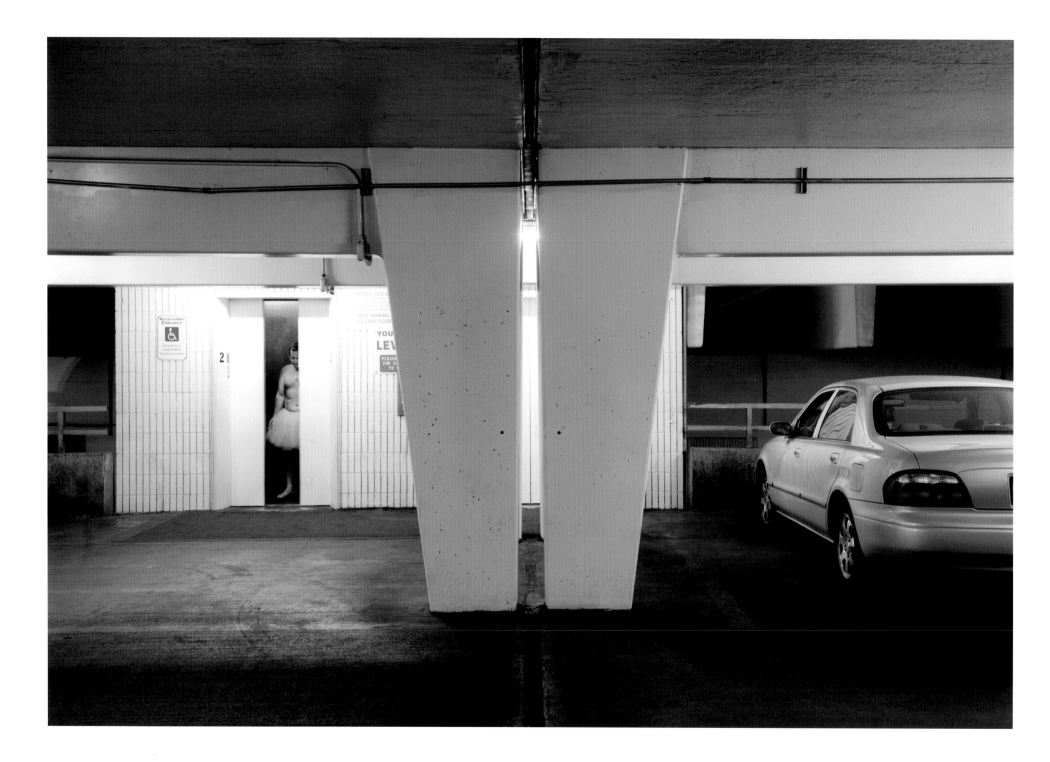

ELEVATOR LAS VEGAS, NEVADA 2008

FERRY LEWES, DELAWARE 2008

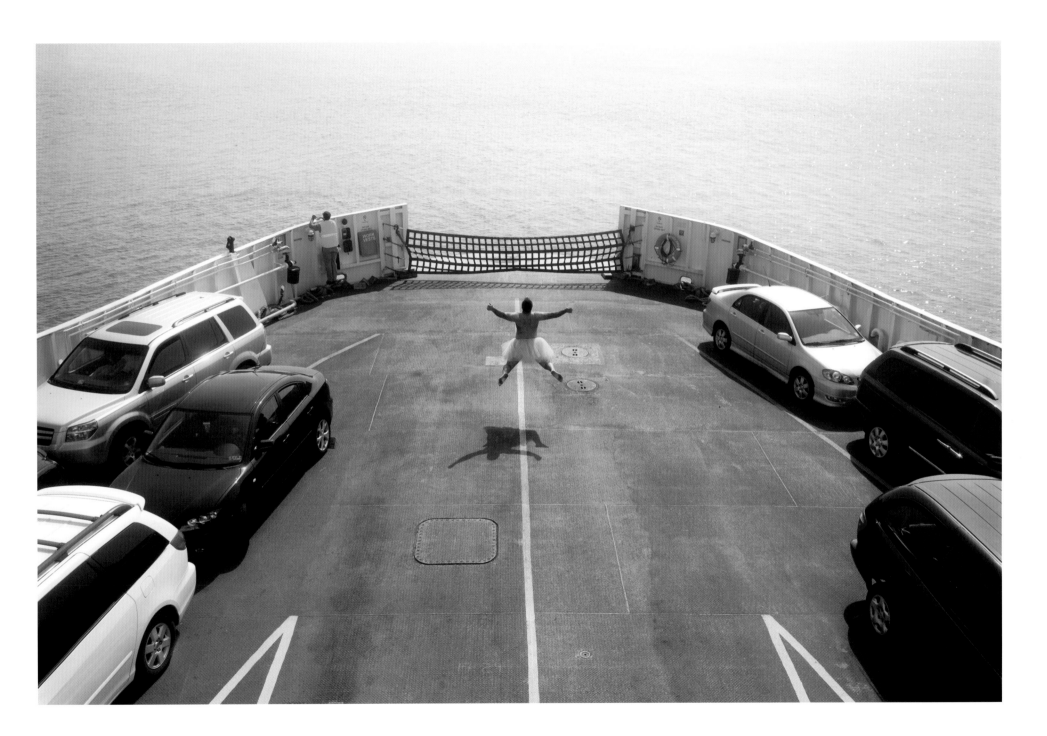

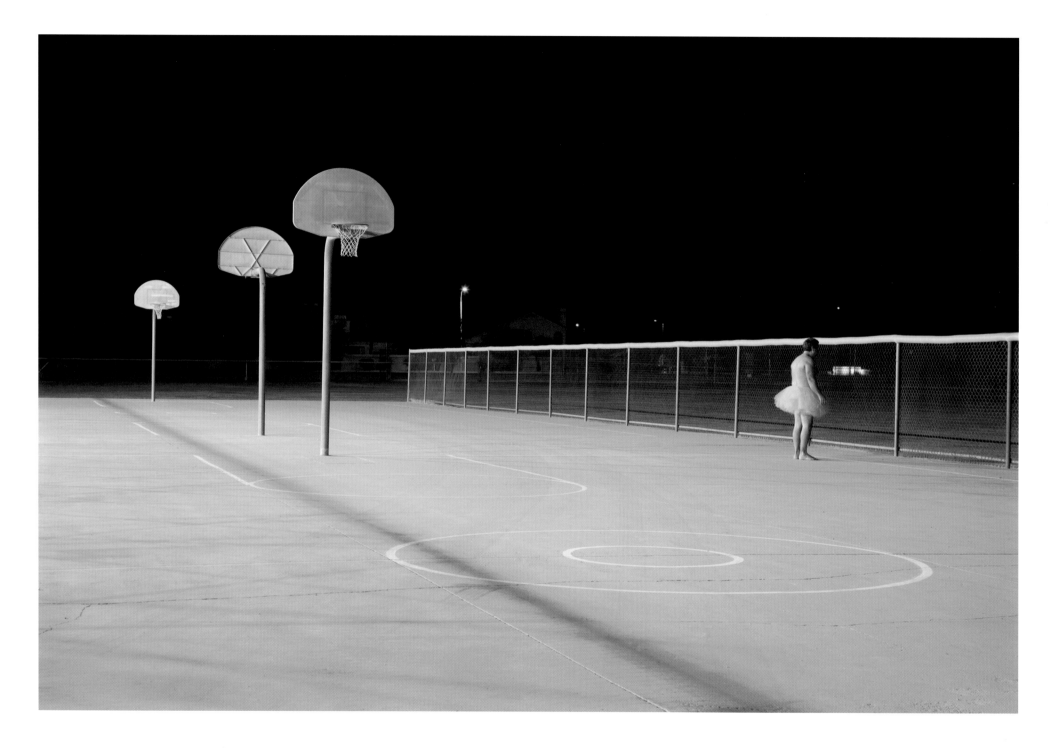

COURT CHANDLER, ARIZONA 2008

GRAND CANYON GRAND CANYON, ARIZONA 2009

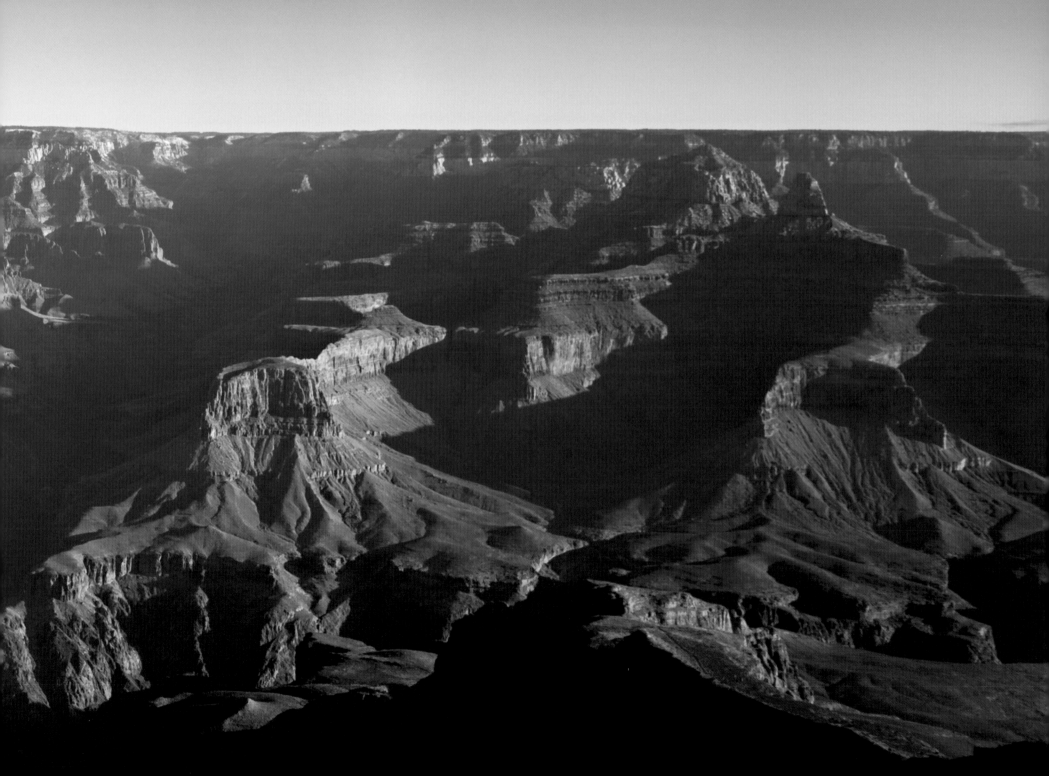

SUBWAY BROOKLYN, NEW YORK 2009

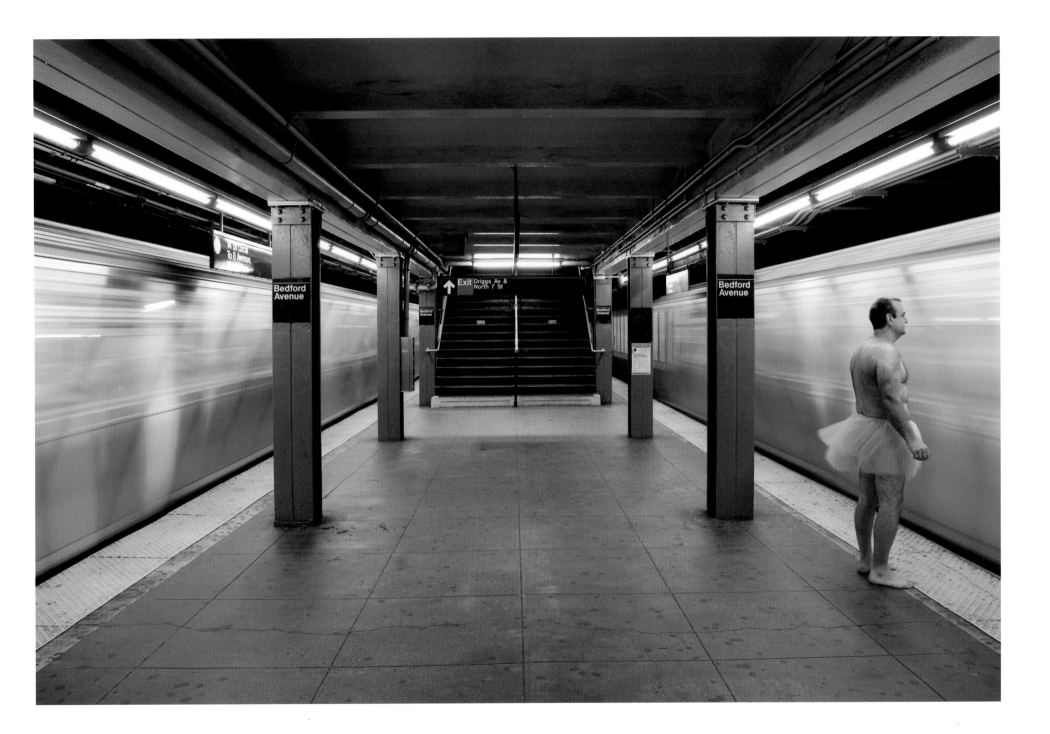

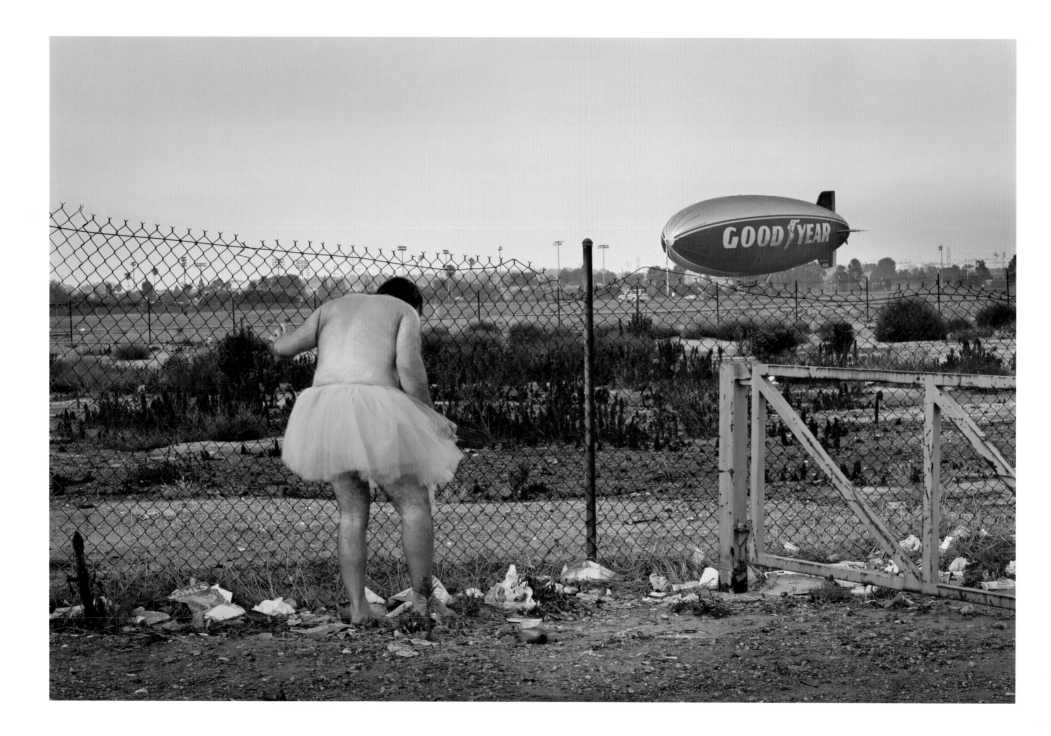

BLIMP CARSON, CALIFORNIA 2008

TUTU SHARON, PENNSYLVANIA 2005

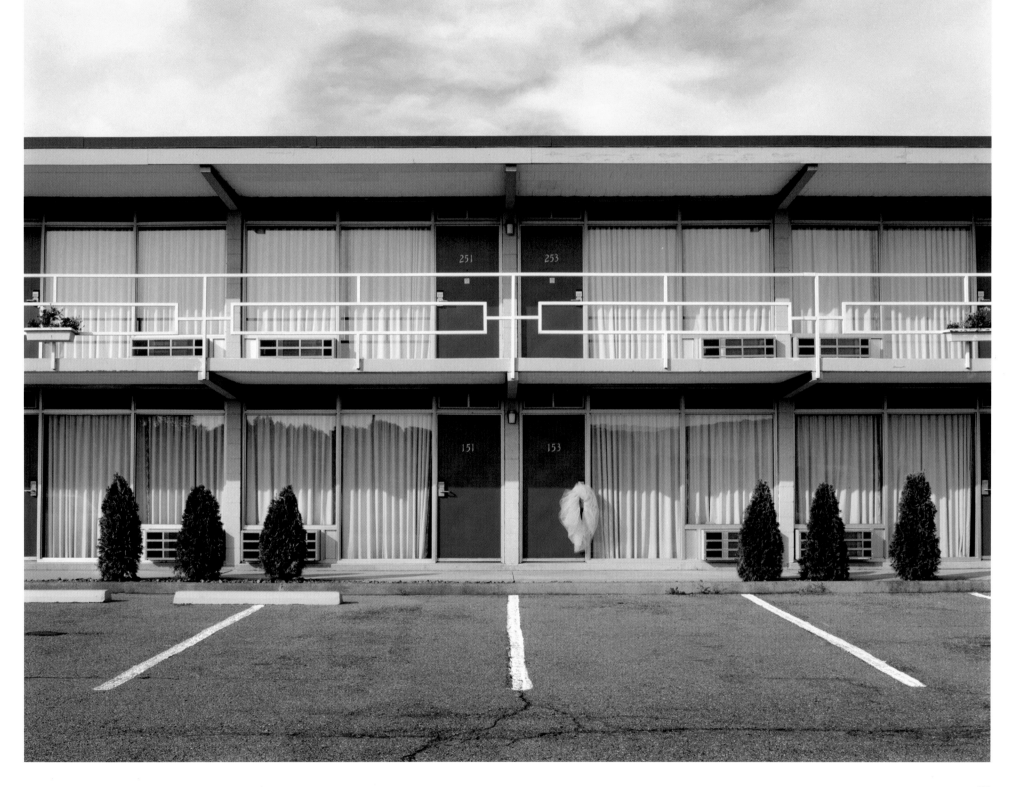

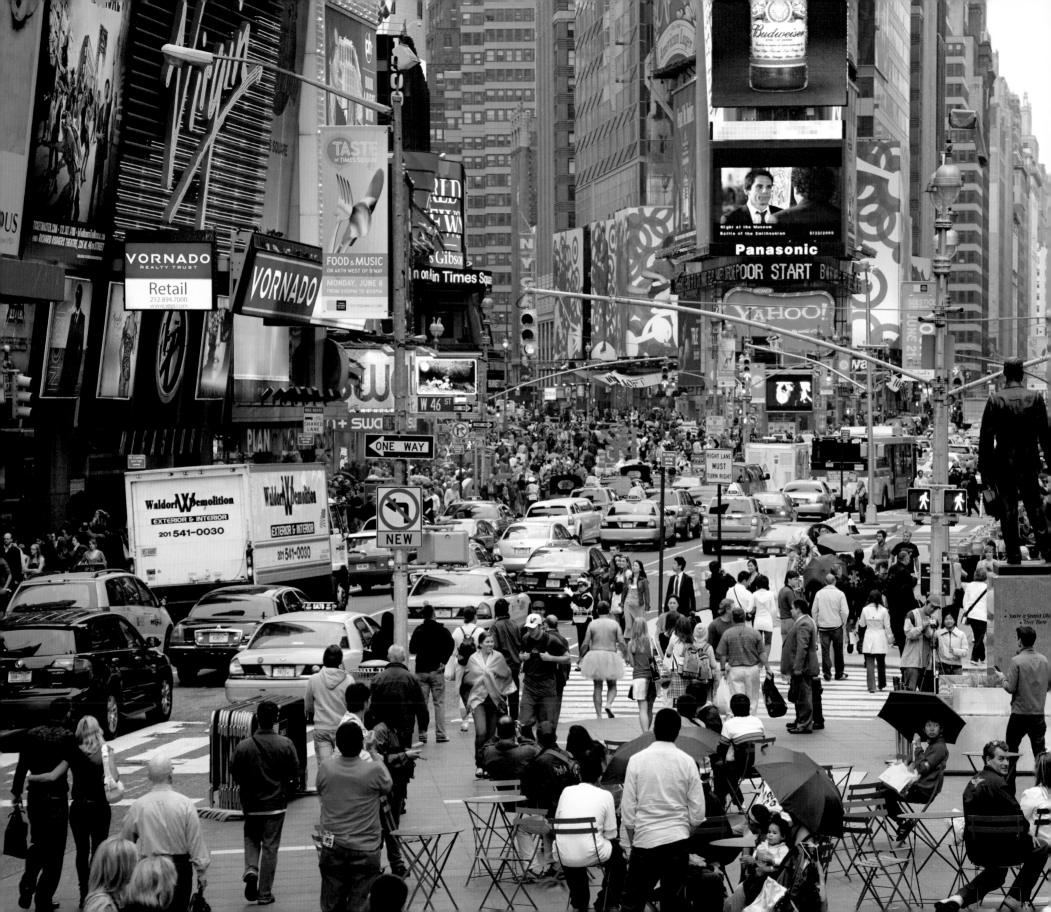

STORYTELLING

THE STORIES BEHIND THE IMAGES

By Kathleen Vanesian

Back in February of 2010, artist-photographer Bob Carey first unveiled a small selection of fourteen of his pink tutu photographic images at an exhibition mounted at Bokeh Gallery. Bokeh is a well-known photographic gallery in the arts district of downtown Phoenix, Arizona, operated as a labor of love by Wayne Rainey, a friend of Carey's. A long-time fan of the artist's work, I reviewed the exhibition for the *Phoenix New Times* website. In preparation to write about it, I interviewed Bob extensively about this particular body of work and its genesis.

In 2003, Bob, a native Phoenician, had moved with wife, producer, studio manager and helpmate, Linda Lancaster-Carey, assistant Justin Rowley, two rescue dogs and an entire professional photographic studio to an old brick industrial building constructed in 1865 in Brooklyn, New York. Despite the move east, he never lost contact with his homegrown Arizona roots. In many ways, it was fitting that the first tutu images were shown in Phoenix, since that's where The Tutu Project was initially spawned the year before he left for New York.

After several laughter-filled hours of interviewing Bob at Bokeh Gallery, I realized that the back stories that went with Carey's tutu photos were just as entertaining, insightful and often unsettling as the photographs themselves. Since then, I have recorded a number of interviews in which Bob explains what was actually going on behind the scenes as he was shooting particular tutu scenarios over the past nine years. Carey's now famously attention-grabbing images were obliquely inspired by the artist's involvement in a 2002 *pro bono* Ballet Arizona project in which hand-picked artists were asked to photographically interpret the meaning of ballet to them personally. Never having been to a ballet performance and essentially clueless as to the difference between a *plié* and a *pas de poisson,* Bob Carey responded – with the help of wife Linda and an assistant wielding a razor – by shaving his entire body and painting it a shiny silver, a signature look that appears in many of the artist's older black-and-white photographs. The look was complete when he donned a ballerina's pink tulle tutu and bowed butt first to an imaginary audience.

Artfully silhouetted and rendered in ethereally glowing black and white, the image captured both impertinent playfulness and agonizing isolation and vulnerability, themes which run throughout much of Carey's work.

On the 2003 road trip to New York, while visiting a friend in New Mexico, Bob serendipitously decided to photograph himself again in the now discarded tutu that was stuffed, along with a thousand other things, in the back of his van. Thus, unbeknownst to him at the time, was born The Tutu Project, which he and Linda have worked on for the last nine years.

The project became even more critical to both when Linda was diagnosed with advanced breast cancer in 2003 and was forced to undergo grueling chemotherapy and radiation treatments. Because of a recurrence in 2006, she is still undergoing treatment today. The Tutu Project is Bob's unique way of psychologically supporting not only Linda with her on-going challenge against this deadly disease, but everyone who has been stricken with or touched by it. As Bob has said, "During these past nine years, I've been in awe of Linda's power, her beauty, and her spirit. Oddly enough, her cancer has taught us that life is good, dealing with it can be hard, and sometimes the very best thing – no, the *only* thing – we can do to face another day is to laugh at ourselves, and share a laugh with others."

To that end, net proceeds from the sale of this book are being donated directly to breast cancer organizations, including Cancercare.org and the Beth Israel Department of Integrative Oncology Fund.

In working on The Tutu Project, Bob and Linda have known both the kindness and meanness of strangers. They have elicited laughter and tender-hearted help from onlookers, as well as not-so-nice taunts, not to mention a number of interesting interactions with various and sundry police departments. The following are some of the background stories – in Bob's own words – about how particular images came to be.

BARN SANTA FE, NEW MEXICO *P. 6*

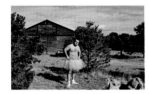

THIS IS AN IMPORTANT IMAGE FOR ME because it was the first Tutu Project shot I ever did. It was taken on the way to New York when we moved there from Arizona, where I lived for 42 years. I was with my wife Linda, my assistant Justin Rowley, my two dogs, my van and a 25-foot moving truck that my assistant and I drove the whole way there.

We planned to stop in every city where we knew people and could park the truck, which had everything we owned in it. Our first stop ended up being Santa Fe, the home of photographer Renie Hiaduk, whom I had met at a Santa Fe Photo Workshop where she is director of programs.

I had the tutu, left over from a Ballet Arizona project, with me and we were talking about doing shots all across the country with me wearing it, but I really didn't think about it too much. Before we left Renie's, I said, "Hey, let's do a really quick shot with the tutu." I don't think I had any underwear on in that one. At that time, I really didn't care. I put on the tutu, but still had my socks on.

The look on my face is one of semi-disgust. I refused to take my socks off because there were stickers on the ground, though they were going through my socks anyway. I figure I had my socks on because I wasn't committed to the project at that point. When I saw the film, I thought that the shot was funny, though it was too bad about the socks. From then on out, I took my socks off.

ROLLERCOASTER WILDWOOD, NEW JERSEY *P. 10*

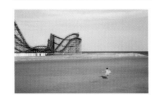

ROLLER COASTER, FAME, BLUE PALMS, GIRAFFE AND MOTEL, WILDWOOD, NEW JERSEY were all shot on the same day during a road trip Linda and I had taken in April after my father died. Wildwood is a resort town on the Jersey Shore that really doesn't come alive until after Memorial Day, so the place is fairly deserted until then. I only did a total of three heel-clicking shots in front of the roller coaster; for some reason, I'm a good jumper and I did different kinds of jumps, but this was definitely the keeper.

After we shot *Roller Coaster,* Linda and I are standing on the boardwalk. We're ready to shoot me from the back near a snack bar where they put a Goofy Golf on the roof, these miniature golf courses you see on every corner along the East Coast. This one had huge animals, including a giraffe. The camera's set up. I'm in my tutu. This man and his son, who was probably 16, come up to me, then the guy turns to his son and says, "That's why I'm making you exercise." It took me about 30 seconds before I realized that he was talking about me and basically saying I'm a fat ass.

SHUFFLEBOARD MESA, AZ *P. 16*

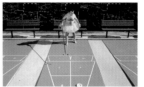

I SHOT THIS IN A LUXURY TRAILER PARK (it's called a "manufactured homes park" now) where my dad lived in Mesa, Arizona. The place had all kinds of restrictions and requirements, and lots of amenities, including the shuffleboard court.

I don't think Dad ever really understood what my artwork was about, but, no matter what, he always was supportive. When we were doing the shot on the shuffleboard court, my dad was really being funny. We were using a strobe because the scene was backlit; Dad's holding the light, moving it around for me at my direction and flashing it, while Jackie Mercandetti, my assistant, was manning the camera.

I think Dad was really intrigued by the whole process of making a photograph. His friends would walk by, and he would point at me and tell them, "That's my son." He was very proud of me, despite the fact that I was standing there in a tutu playing shuffleboard. When he was dying, we got to talk and he told me how proud he was of me. Even when he was upset with me, we always had a way to communicate.

MOTEL WILDWOOD, NEW JERSEY *P. 23*

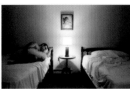

AFTER SHOOTING ALL DAY, Linda and I were trying to find a hotel, but couldn't find a room anywhere. Finally, we drove up to this place. The owner lived there; though the rooms weren't really ready yet for guests, he rented us a room and didn't have a problem with our dog Sofie staying there with us. We wouldn't normally stay at a place like this, but beggars can't be choosers. When I walked in the room, I loved it, even though it smelled musty and ocean damp. While the sheets were clean, if you walked on the carpet barefooted, it was kind of gnarly, so Linda wore her shoes the whole time.

We got to the room probably around midnight or one in the morning. When we walked in, Linda looks at it and says, "Oh, God." I looked at the painting of a little girl hanging on the wall; if you look in its right-hand corner, she's sitting on a bench and putting ballerina shoes on, like a bad Degas impression. I had to shoot this even though it was around 1:30 or 2 in the morning, and Linda was cranky.

For some reason, I really loved this hotel. It wasn't dirty; it was just slightly worn. I don't think it would have gotten much better no matter what the guy did to it.

WASHINGTON MONUMENT WASHINGTON, D.C. *P. 27*

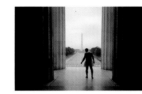

AFTER I DID MY LINCOLN MEMORIAL SHOT, I began looking for another shot. I couldn't even think about using the reflecting pool area on the Mall as a backdrop. It was under construction for some reason and a big mess. So I did my 180 degree trick; I turned around and there was the perfect Washington Monument shot.

By the time I finished, it was 5:30 a.m. and the sun was just coming up. A jogger came up and smiles at me in my tutu. I told him it was for a cancer awareness project. He shook my hand and pulls his pants down to show me his scar from having one of his kidneys removed last year because of cancer. "By the grace of God, I'm still alive. Thanks for doing what you're doing," he said. That made the whole trip.

As I was leaving, 75 marines were running up the stairs (I didn't have my tutu on). I made sure I went to the office and gave the Park Police who covered for me Tutu Project stickers and T-shirts. That was a special picture.

PALM TREES I-10, CALIFORNIA *P. 30*

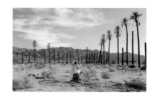

I THINK ANYONE WHO TRAVELS ON I-10 through the California desert between Blythe and Indio is mystified by the sight of these palms trees planted in strange geometric formations in the middle of nowhere. Actually, they're in Desert Center, which is in the middle of nowhere. I found out later that, in the early 1990's. Stanley Ragsdale, a traveling preacher from Arkansas and the founder of Desert Center back in 1921, commissioned the planting of the palm trees on the town's frontage with the freeway. When asked why, he said he always wanted a "tree-ring circus." Since his death in 1999, the trees haven't been tended to and many have died.

If you drive around the tiny town, you can see a run-down, boarded up hotel; it's like a ghost town, though I think people still live there. There are so many of those in the desert; places people thought were going to be popular or a good truck stop. The Salton Sea is another one. I was by myself with my trusty remote on this trip.

FALLEN TREE LONG ISLAND, NEW YORK *P. 38*

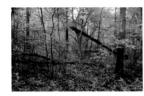

LINDA AND I DECIDED TO GO ON A HIKE, since it was a really hot day. We took Sofie, our dog, and got on the Long Island Expressway, arriving at a park area with a trail. I did this shot with Linda videotaping me, and was walking up this log that was all slimy – if I had slipped, I could have been impaled by a tree limb. Just my luck.

As we're on our way home, the van breaks down in the middle of the L. I. Expressway, which is a true emergency situation since there's really no place to pull over and cars are whizzing by. We pulled over to the inside lane, which has barely enough room to park a vehicle. It was completely insane and dangerous and very scary. The only thing you can do is call 911, which we did. And pray. Within four minutes, two tow trucks appeared – they have tow trucks on the frontage roads just waiting for breakdowns, it's that bad. One truck had to block traffic so the other could get to us and tow us away.

TIMES SQUARE NEW YORK, NEW YORK *P. 40*

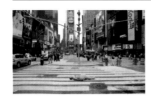

I ALWAYS THOUGHT NEW YORK'S TIMES SQUARE would be the Holy Grail of ballerina pictures. When I started the whole project, I wanted to do Times Square, but I thought it would be the craziest – and hardest – one to do. Actually, it was the least crazy out of all the tutu images because nobody really cared what I was doing.

I didn't have a permit and the only time the police approached me was when I walked over to their horses. I was five feet from them, carrying a remote, since I was shooting with a camera across the street. One of the cops said, "Why?" And I replied, "Why not?" Then he asked me whether I had anything on under my tutu. I actually have a shot of me pulling up my tutu to show them my pink gym shorts.

During all of this, we were forty feet from The Naked Cowboy. He's that buff singing guy who hangs out around the area, rain or shine, serenading the crowd dressed in nothing but a cowboy hat, tighty whities and a guitar. Nobody was looking at him at the time we were shooting. I guess a hairy half-naked man in a tutu trumps even a hot half-naked cowboy. This was taken the same day I did my magical subway picture.

DIVING BOARD RIDGEWOOD, NEW JERSEY *P. 48*

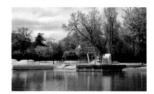

I ALMOST GOT ARRESTED over this shot. I was with *The Today Show* film crew, who wanted to get me in action. I knew of this man-made lake location that's emptied halfway in the winter for ice skating. It was still half empty, with weird little islands and diving boards.

With the camera man, sound man and producer, we drove into the parking lot without permission – there was no gate and a meager "no trespassing sign except for residents of Ridgewood with passes." I put on my tutu and climbed up on the high dive, which was really bouncy. I turned around and hung my heels over the edge, when I heard kids yelling, "Jump, jump!" Then here come all these policemen, who yelled at me as I got down; then I see all these adults lining the fence, looking in.

I guess half the town had called 911 to report I was going to commit suicide. We tried to explain what we were doing, but no one was buying it. The park manager came and told us we should have gotten a permit; the cops said we were trespassing, and wanted to know whether the manager wanted to press charges at $1,000 a head, which he didn't. The soundman finally turned to me after the smoke cleared and said, "I've been to Afghanistan five times and this is the closest I've been to getting arrested." Later, I noticed the crew talking to some official honcho in an SUV. Turned out it was the police chief. When I walked up to the car, he asked, "Are you the ballerina?" When I said yes, he replied, "I think you're doing a great thing." We ended up getting newspaper coverage on this escapade.

FLAG TIMES SQUARE, NEW YORK *P. 51*

I LOVE THIS FLASHY FLAG in front of the Armed Forces Recruiting Station in Times Square. Traffic is really close to it. My assistant is triggering the camera from across the street, when two cops come up to me and one asked, "Excuse me, sir, are you well?" "Yeah," I answered. "Fine. I've been doing this project for nine years."

"Okay, no problem. We just wanted to make sure you were 'okay.' And, like, not have some problems going on." "I have problems," I replied. "But this is not one of them." "Okay, just be careful," the cop warned. "This is a crazy part of the street; if you step out one foot, you'll be mowed down."

On top of this, there was a kind of crazy guy talking to the cops. Then he looks at me and starts making weird sounds. "Dude," I said. "Mellow out, man. This is all for breast cancer." That calmed him down and he said, "Sorry, man, sorry." It was like I had said the name of the Lord and he was magically healed.

ROCK WALL GRAND RAPIDS, MICHIGAN *P. 55*

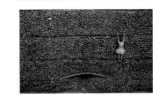

I HAD GONE TO A WEDDING with Linda the night before I took this. The next day, I drove to Chicago, picked up my intern, Hillary Erdmann, from the airport and we headed out to Grand Rapids.

This wall, scouted out by Hillary, is actually part of a drainage ditch and the wall is at a 45-degree angle, so that's why I could lay on it. The hardest thing about this shot was trying not to fall down the rocks. And it hurt – I had had shoulder surgery and was having to reach over my head. Plus I didn't have any shoes on.

BOAT DOCK ROCKAWAY, NEW YORK *P. 71*

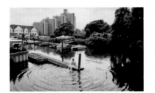

EVEN THOUGH THIS LOOKS LIKE AN IDYLLIC SCENE, it was far from it. This was a boat store that had gone out of business, so the place had really been abandoned. I might have been trespassing in this one. I don't know how I got there, to be honest.

There was one boat sitting out front that had graffiti scrawled all over it, docked in this water that was completely gross. I think I saw a dead rat floating in it. When I put my feet in the water, I thought they were going to dissolve in it, it was that gross. It was the nastiest water in the world. What I won't do for a shot.

MOTOR HOME PRIMM, NEVADA *P. 77*

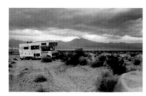

I WAS ALONE AND ON MY WAY from Las Vegas to Los Angeles when I took this picture. I stopped in the middle of nowhere at a place called Primm, Nevada, which is about 40 miles outside of Las Vegas. It claimed to be the home of Buffalo Bill's Desperado Roller Coaster, for one brief moment the world's tallest. I was driving a rental car (an economy special, not some SUV) and decided to go off the road. I really wanted to work the roller coaster into the shot, but I started driving down a dirt road and spotted this abandoned motor home, with a crazy storm coming in on the horizon.

I set up some lighting equipment, sandbagging it to keep it from going down in the wind. I was using a $6,000 Nikon rental camera I had from a job I had just finished. I started shooting. The next thing I know, this beautiful storm in the distance was on top of me. I had the rental car doors open to access equipment. The wind was so strong that it blew over my equipment, and turned my reflector into a giant taco. It started raining like crazy; I wiped the camera off with clothes from my suitcase, wrapped it in a t-shirt and stowed it in the back seat.

When I got into the car, all I had on was my pink shorts – no shoes, barefooted in the desert with all these stickers, no shirt on. I'm soaked to the bone. Inside the car there was a heavy layer of red dust because the wind had gone through it like a tornado. Then I notice it's raining so hard that the road is turning into a raging river from a flash flood. Luckily, I was able to get through the fast-rising water and mud to the highway and left.

BLUE PALM TREES WILDWOOD, NEW JERSEY *P. 81*

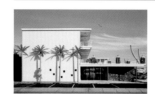

WILDWOOD IS VERY STRANGE, especially when it's off season — really frozen in a funky past. Linda and I immediately spotted this place with its blue fiberglass palm trees, which are everywhere in town – leftovers from the 50's and 60's, and mid-century modern architecture.

We ended up watching some guys on a lift painting and putting plastic tops from winter storage on the fake palm tree trunks. As we were watching this, I told Linda, "I have got to do this shot." I went inside and got permission to shoot. I really wanted to climb one of these palm trees, but I'm too fat and there was no way I could do it by myself. Linda brought a prop box over for me to stand on. As soon as I yelled, "Pull it out," she'd take the box and run out of the picture, and I would shoot it with a remote I had in my hand. Every time I latched on to the tree, I could feel those fiberglass shards going into my chest. When I couldn't hang on anymore, she'd run back in and I'd stand on the box again. All the while, kids were walking by. Looking at the photo, those funky 50's trees are as out of place as I am. And if I got to the top, what was I going to find – a blue coconut?

PULASKI SKYWAY NEWARK, NEW JERSEY *P. 82*

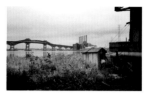

THIS WAS TAKEN ON THE ROAD leading to Port Newark Container Terminal, the massive shipping yard in Newark where containers coming in and out of the port are stored. It's one of the biggest ports on the East Coast. Containers from all over the world come there, then semis drive down the road that's right behind where we planted my tripod to shoot this picture. In the background is the Pulaski Skyway, a four-lane freeway made up of a bunch of bridges that connects Newark and Jersey City.

To be honest, it was really filthy there. My assistant and I did a couple of shots. As we were working, one semi stopped and ten more were behind him. Two guys in line were hanging out of their truck windows, taking pictures of me with their camera phones, yelling and giving me a thumbs up. They thought it was great.

Usually, the cops come when we're just about ready to leave. And, sure enough, as we were breaking down, here come the officers of the law. But this time, it was a Homeland Security car. They told us that the area has the most surveillance of any area in the United States, especially since 9/11, which we obviously didn't know. "How am I supposed to know that?" I asked. They were cool, but made it clear that it would be very good if we left. We did. They were really very nice to us.

HIGH DESERT ROAD MONUMENT VALLEY, UTAH *P. 91*

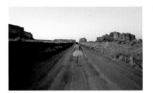

THIS IS ONE OF THOSE "freezing my tutu off" images. I was in Monument Valley by myself; it was 15 degrees out and, though you really can't see it in this picture, there was actually snow on the ground. Earlier in the day, I had been running around in my usual uniform of jeans, T-shirt and flip flops and had shot scenes in several places, including *Three Horses, Monument Valley,* when there was light out. At that point, I really didn't realize how cold it was.

I fell in love with this desert road scene the minute I saw it and wanted to capture it when the sun wasn't blasting, so I came back after the sun had just gone down. I was forced to shoot at 1600 ISO, a very fast film speed with one second exposure and a very slow shutter speed, because it was dark out. I stood totally still for this one; when I finished, I was so cold I could barely make it back to my van.

FAME WILDWOOD, NEW JERSEY *P. 95*

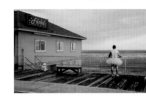

IT WAS THE SAME MORNING we shot *Roller Coaster.* It was gloomy and kind of wet out. I have to be honest – I'm kind of dense when it comes to finding hidden meaning in my surroundings. I was just drawn to the hot pink color of this little place on the boardwalk where they sell cellular phones. If you look out on the sand, you'll see where a grader had scraped all the trash off the beach. What you don't see is a guy walking back and forth with a metal detector and shovel, digging up crap out of the sand.

LINCOLN MEMORIAL WASHINGTON, D.C. *P. 99*

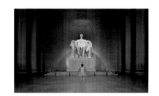

WHEN I GOT TO D.C. IN THE EVENING, it was 7 p.m., but still light out. About 1200 people were still there – tourists, kids, classes, tour buses, the usual. I went up to three young United States Park Police standing around, hanging out and talking. I showed them what I was doing and said I really wanted to do a shot of the Lincoln Memorial when there's no one around. "What time does this close?" I asked. They said it never closes; it's open 24 hours a day.

Technically I needed a permit, which I already knew, but they told me that if I came back between 3 and 4 a.m., they'd be there and wouldn't tell anybody. I crashed at a friend's house. Linda calls me at 4 and asked if I got the shot. I missed it. I collected myself, so I wouldn't freak out. Got there at 4:30 and started pulling up to the parking area, but there was a police car parked across the street just sitting there. There's a four-mile radius where you can't park between 10 p.m. and 8 a.m. I called Linda, who told me to drive until I could park legally, then get a cab. I parked four miles away and grabbed a cab.

When I got to the Memorial, nobody's there. I started setting up and two of the same cops come out of a corner office and say, "You're late." I apologized. They said it was too late to do it. I asked whether they would talk to the guys coming on duty about this. Eventually, a guy with a bunch of decorations on his chest walks up and says, "Don't worry, man, we got your back. Go ahead and do whatever you want." As I was shooting, I noticed that the cops in the office were taking pictures of me with their phones and laughing.

HORSES ELMIRA, MICHIGAN *P. 103*

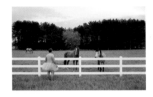

I WAS AT MY SISTER-IN-LAW'S HOUSE for a memorial because her husband had passed away. When I go to those family things, I have to head out and do my own thing. I found this picture-perfect scene – the fence was perfect, the horses out in the pasture were perfect. When you get closer to horses, they naturally come up to you, I've found. Cows and horses, they all want to get close. It's weird. Then they walk away.

I go up, I shoot it. It was amazing because everything was just perfect; it was one of those special moments. I was there and a truck pulls up on the road and then turns in. I can't remember whether the driver said something to me – he might have been the owner of the place, but he was nice and kind of laughed at what I was doing.

My sister-in-law Lori went to work a couple of days later and her friend said, "Is your brother-in-law in town? Because I was listening to the police scanner and I heard there was a ballerina on Mt. Jack Rd., so I thought he might be here." "Yeah," she replied. "They were here for three days and just left." Yet another ballerina sighting.

PARKING LOT TEMPE, ARIZONA *P. 104*

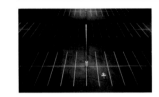

I REALLY LIKE MULTI-LEVEL PARKING STRUCTURES for some reason and this one in Tempe, Arizona near Arizona State University was all lit up with a nice blue light at night. Excited, I thought, "Man, there's got to be a shot in there," so my assistant Nate Woodruff and I drove around in circles for 20 minutes scoping the location. I was forcing myself to find something interesting and there was nothing there – or so I thought.

So I have this rule: What do I do next if I don't see a shot? I turn around 180 degrees and you never know. I turned around and there was this parking lot in front of me, perfectly lit with no cars in it at all. I got down from the sixth floor of the garage to the parking lot, taking a cheap Chinese remote control with me, which ended up not working. Luckily I had somebody with me and we set up a number of possible images. By this time, it's about quarter to one in the morning, and here comes this huge UPS semi that pulls into the lot and parks in my shot. He's got to see me since I'm the only living thing around. So we sat there waiting for the semi to move, but he didn't pull out. Finally, I ran up to the driver in my tutu and asked him if he could move. He did, but didn't really react too much, which was weird.

THREE HORSES MONUMENT VALLEY, UTAH *P. 108*

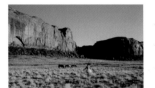

I WAS SORT OF STALKING THE HORSES you see in the picture. When I'm around animals, I walk really slowly. Sometimes I turn my back to them, but have my head turned around so I can see if they're coming at me.

I was trying to get as close as I could to them. Then I hear this crazy sound; I looked toward the sound and there's a horse across a nearby dirt road and he's going nuts. He started charging towards me, so I left the camera there, ran to the car, opened the door and jumped in.

The horse ran by me like he was really enraged because I was getting too close to the other horses. He was a boy horse and I think the others were girls. It looked like he wanted to make sure I was not hitting on his harem. I was by myself – again. There's not even cell phone reception where I was.

PARKING GARAGE LAS VEGAS, NEVADA *P. 116*

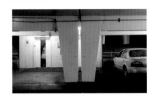

I THINK THIS WAS AT THE GOLDEN NUGGET CASINO parking garage in downtown Las Vegas, which is totally old school. I was with my photographer friend, Greg Preston, a professional photographer specializing in shooting casinos, and his assistant, Todd Miller. We had the camera set up and I was loitering around in my tutu. I was getting on and off the elevator, and people were laughing at me. As we were shooting, it was like we were in high school again.

At one point during the shoot, I was running to go back to the elevator. I stuck my arm into it and the doors shut on my arm, so I grabbed them and pulled them open. The elevator's mechanical parts were exposed and an alarm went off; screaming and laughing, we ran off like kids, even though we knew we were being videotaped on security cameras.

FERRY LEWES, DELAWARE *P. 119*

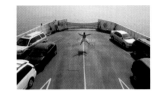

WE WALK OUT ON THE DECK OF THIS FERRYBOAT, a clear, steel deck with a few cars parked on it, in the fog. It was like we were floating in space. Of course, I had to shoot this because it was so beautiful.

How am I going to do this? I found a crew member with an orange vest on and asked him if I could get my picture on the platform. He told me no problem. I told him the only problem was that I was going to be dressed in a ballerina's tutu with shorts underneath. He laughed and said it was fine, though he said that where I was going to be standing, the captain will see you first thing. I told him I didn't care.

I set up my camera on the observation deck, with Linda manning it. Curious people were on each side of her. I start getting nervous and walk to the car, undress, put the tutu on and grab a cheapo remote control from China to trip the camera shutter. I took a couple of deep breaths and ran out to the deck. There was a guy with a safety vest on at the front of the boat, checking that we weren't going to collide with another boat; there was a phone next to him. I did about 30 or 40 frames of me jumping in 30 seconds when the phone rang. It's the captain, who thinks that I have a knife or that I'm ready to detonate a bomb with my remote, which has an antenna. Within seconds, crew surround both me and Linda, screaming, "Take the tutu off now!" I did. People around me were yelling at the crew to leave us alone, that we weren't doing anything wrong. They let us go only after I showed them my portfolio of tutu shots and explained what I was doing.

SUBWAY BROOKLYN, NEW YORK *P. 125*

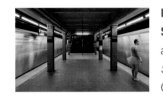

I CALL THIS MY MIRACLE SHOT. We did this right after we did *Times Square*. My assistant, Gemma Fleming, who's an amazing artist, was there. I said, "Okay, we're going back to Brooklyn from Manhattan." We got back to the Bedford subway stop in Brooklyn, in an area called Williamsburg, which is the hipster capital of the world – it's always crowded and bustling. Miraculously, this shot was done at 7 o'clock on a Friday night, when the place should have been packed.

This all happened within ten minutes. I scoped the shot, making it as symmetrical as possible, then thought that it would be cool to capture the wind blowing my tutu. I also wanted both trains coming in at the same time; if I couldn't get that, I decided to just shoot one where I'm in it with the train moving, and the other side I'll add in with Photoshop. But both trains actually came in at the same time!

I shot really fast, holding my breath and staying stock still while setting off the shutter with a remote I was holding in my hand away from the camera. We had to walk home; Gemma said that I had to wear the tutu with just my shoes on for the 15-minute walk to my house. And I did it.

ACKNOWLEDGMENTS

To my sponsors, my dream has become a reality. Thank you from the bottom of my heart.
And to the very special people who helped bring this book project to life, Amy Arbus, Brad Jones, Cindy Puskar,
David Leite, Hillary Erdmann, Judy Smith, Kathleen Vanesian, Kim Krejca, Laurie Kratochvil, Marc Simpson,
Marcela Shine, Margaret Dixon, Peter Shikany, Rick Gayle, and Tim Richards, thank you!

Abigail Doyle	Audre Broers	Christine Homan	Delores Busch	Heather Leon	Jenny Moss Copywriting
Alan Fitzgerald	Barbara Crisp	Christopher Keech	Denise Hale	Henry Mattison	Jenny Sanders
Alexis Light	Betty Jordan	Cindy Griffis	Doc and Angela Dickson	Howard Bates	Jim Callahan
Alicia Rivero Yamada	Bob Galloway	Corinne Myra	Edie Rogat	Howard Embry	Jim Hamlin
Alyce Stewart	Briana Buban	Craig Stull	Elisabeth Santos	Ingenuity Design	Jodi Snyder
Amanda Shuttleworth	Brittany Kammerzell	Crystal Duffie	Emily and Bart Thrower	J Lawrence Snavely	Joyce Hoffman
Amber Lowi	Carol Vaughn	Cynthia Jeffrey	Erica Starway	James Bayliss	Joyce Project
Amy Kiernan	Carole Wunderlich	Dan Shankman	Erin O'Brien	James Olsen	Kang-ning CHEN
Amy Pieroni	Catapult Strategic Design	Daniel Portnoy	Frank Ellsworth	Jane Wheeler	Katherine Boutry
Andrea Levitt	Catharine Orn	David Breschi	Gayle Robinette	Janet Jeffries	Kathleen Berkowitz
Andrew Muir	Charla Rolph	David Breslauer	Glenn Salyer	Janet Shoffner	Katie Szrom
Andrew Wicklund	Cheryl Miller-Akers	David Coven	Gordon O'Neill	Janine Eggers	Keith Roberts
Angel Martin	Chris and Katie McPherson	David Siegel	Grace Carter	Janine Smith	Kimberly Alaniz
Anne Connor	Chris Zawistowski	Dawn Brinker	Hani Khoury	Jean Lipkin	Kimberly Elsholz
Ashley Gorman	Christine Chronis	Deborah Correnti	Hanz Mink	Jeana Carey	Kimberly Scott